LAKE POWELL
A DIFFERENT LIGHT

LAKE POWELL
A DIFFERENT LIGHT

PHOTOGRAPHS *by* JOHN TELFORD
with TEXT *by* WILLIAM SMART

GIBBS·SMITH PUBLISHER

Salt Lake City

Photo Opposite: STAR TRAILS, COTTONWOOD CANYON

First Edition
98 97 96 95 94 8 7 6 5 4 3 2 1
Photographs and photographer's preface copyright © 1994 by John Telford
Text copyright © 1994 by William Smart unless otherwise noted

This is a Peregrine Smith Book, published by
Gibbs Smith, Publisher
P.O. Box 667
Layton, Utah 84041

Design by Traci O'Very Covey
Edited by Gail Yngve
Printed in China by LeeFung/Asco

Library of Congress Cataloging-in-Publication Data

Telford, John, 1944-
 Lake Powell: a different light/photography, John Telford; text, William Smart.
 p. cm.
 ISBN 0-87905-609-6
 1. Powell, Lake, Region (Urah and Ariz.)--Pictorial works.
2. Powell, Lake, Region (Utah and Ariz.)--History. 3. Glen Canyon Region (Utah and Ariz.)--Pictorial works. 4. Glen Canyon Region (Utah and Ariz.)--History.
I. Smart, William B. (William Buckwalter), 1922- . II. Title.

F832.G5T45 1944
979.2'59--dc20 94-18654
 CIP

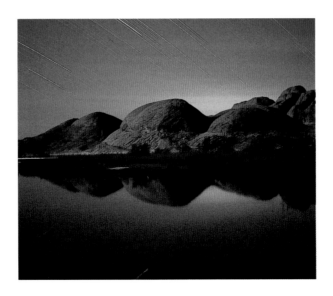

To those who lost something in Glen Canyon and found it again at Lake Powell.

JOHN TELFORD

To those who leave each campsite or vista point or hiking trail cleaner than they found it; who alter no evidence of ancient man's passage; who, as individuals and as part of the body politic, protect the right of future generations to find renewal in unspoiled land; to all these— may their numbers increase—this book is grate- fully dedicated.

WILLIAM SMART

———

ACKNOWLEDGEMENTS

Making photographs on and around Lake Powell for twenty years is difficult without a boat. I've never owned one. I am, therefore, extremely grateful to friends who have shared with me and taken me to the wonderful places where photographs are found. Tom Haslam and Al Taylor exposed me to most of the north end of the lake, while Harold Johnson and Steve Ward of ARA Leisure Services showed me most of the south end. I am indebted to them not only for taking me to magical places, but also for telling me the names of those places, most of which I think are correct. Galen Metz with Eastman Kodak and Ronal Taniwaki with Nikon are valued friends who provided both technical support and stories to tell.

As ever, I am grateful to my loving wife Valerie and my growing family for their support and encouragement while I chase the light.

Thanks to Gibbs M. Smith, Traci O'Very Covey, and Gail Yngve for their parts in the creation of this book.

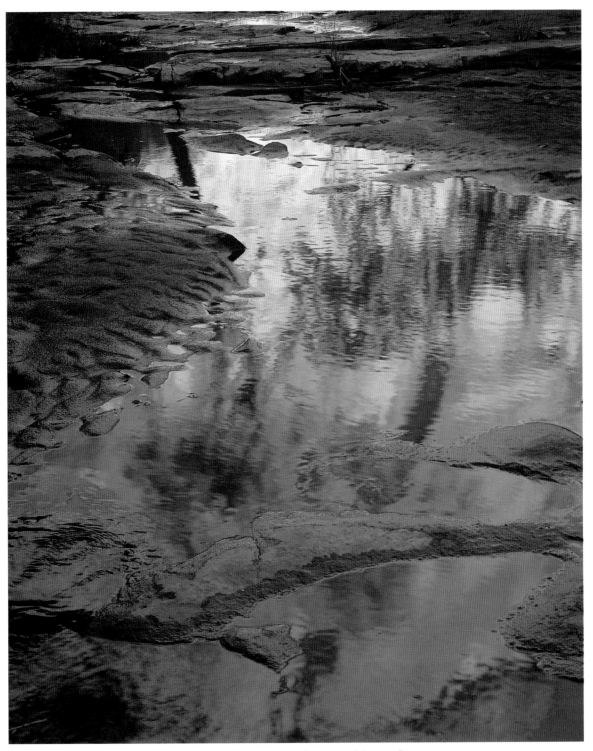

Stream reflection, Seven Mile Canyon

IN MARCH 1963, THE SIERRA Club published Eliot Porter's photographic masterpiece of Glen Canyon, *The Place No One Knew*, just three months after the flood gates of Glen Canyon Dam were closed, which began the flooding of 180 miles of Colorado River and two thousand miles of side canyons and grottoes—Lake Powell.

PHOTOGRAPHER'S PREFACE

I first met Eliot Porter in June 1975, starting a friendship that lasted until his death. During the several photographic trips and conversations we had, one thing became quite clear: Eliot Porter did not like Lake Powell and had no intention of ever returning there. He was just one of a handful of people who knew Glen Canyon and the ghosts that were buried beneath its waters. He spoke reverently of Music Temple, Cathedral in the Desert, and Dungeon Canyon. His photographs still speak eloquently of those lost places, but the loss of Glen Canyon was a bitter defeat for him as well as for all who fought to save it. Like Eliot Porter, it seemed that all conservation groups saw Lake Powell as the manifestation of defeat and consequently abandoned it and its surrounding country. Names such as "Lake Fowell" and "Floyd's Void" speak of the disgust and contempt held for the lake.

I am one of the multitude who did not know

Glen Canyon. My first experiences with the area were in 1972, and then again in 1974, and these started a succession of annual and semiannual photographic trips that have continued to the present. Tom Haslam and Al Taylor took me to places that were literally breathtaking. We would take the boat as far up one of the side canyons as we dared and then set out on foot to explore more. Up sand dunes, through thickets of willows and forests of cottonwood, we would hike and explore, frequently discovering the places where secrets and legends are born.

After one such trip to Seven Mile Canyon, I called Eliot Porter and invited him to go with us sometime. When describing where we had gone and what we had photographed, he abruptly stopped me, saying, "Wait a minute! I know Seven Mile Canyon, and that doesn't sound anything like what I remember."

"Don't forget, Eliot," I said, "the Seven Mile Canyon you knew is gone. The Seven Mile Canyon I know was inaccessible to you. We use the lake to take us far beyond where you could go, and then we start to explore from there."

After a long silence, he said, "For the first time you've given me a desire to return." Several dates were subsequently set, but a heart attack, illness, and finally death kept him from keeping any of them.

I share the loss of Glen Canyon, having frequently floated in Music Temple and Cathedral

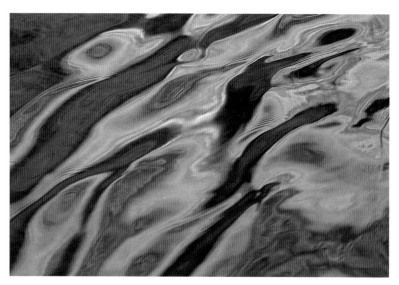

TWILIGHT CANYON

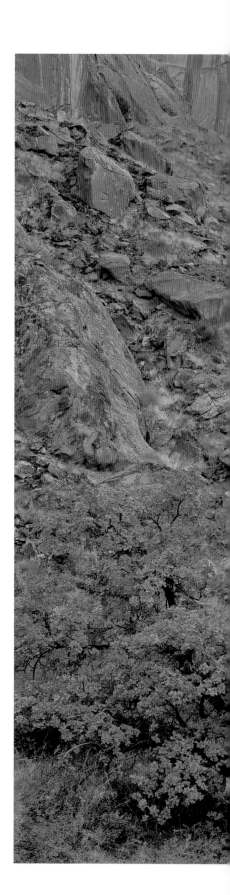

COTTONWOOD, AUTUMN,
SEVEN MILE CANYON

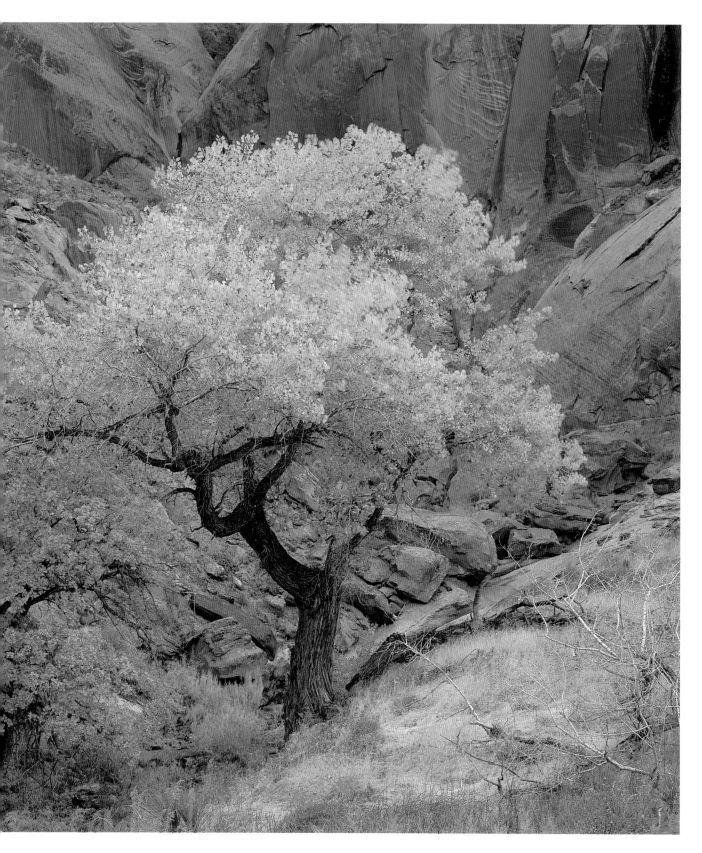

in the Desert with Eliot's photographs etched in my mind, longing to be able to see those places just once as he did. To hear the echo of water trickling over the slickrock through the cattails and maidenhair fern. To smell the spicy aroma of juniper and willows, dreaming away days in solitude. But mourning the flooded canyons and grottoes keeps me from seeing what remains and focusing on today's concerns.

This book is not meant as a celebration of Lake Powell, nor is it a memorial to what was lost. It is a celebration of what has survived and what is still fragile and threatened.

In October 1990, a workshop group that I was teaching with Steve Ward was photographing in Bridge Creek under Rainbow Bridge. Lake waters had flooded Rainbow Bridge National Monument during the high-water years of the early eighties. After nearly a decade of being underwater and as a result of several drought years, Bridge Creek was dry. We photographed the cobbles and reflection pools of Bridge Creek for several hours, then climbed the 200 feet up to the trail. Later, we met National Park Interpretative Ranger Rhonda Brooks, who asked if we knew the significance of what we had been photographing. She then explained that before Bridge Creek was flooded, Rainbow Bridge had been 309 feet above the creek bed. Earlier that summer as water receded from under the bridge for the first time in nearly ten

years, measurements had revealed that the bridge was 290 feet above the creek bed; nearly 20 feet of silt had been deposited over it. She reached in her shirt pocket and pulled out a small notebook journal. After flipping through the pages, she read:

August 20, 1990. Started to rain this morning and continued through the afternoon. In late afternoon a flash flood roared down Bridge Creek. It cut a trench in the muddy creek bottom several feet wide.

August 27, 1990. Another flash flood today. After inspection, we realized the channel of Bridge Creek had been flushed clean of silt right down to the cobbles, indicating Rainbow Bridge is once again 309 feet above the creek bed.

Turning her attention back to us, she said,

"You have been photographing the original cobbles in Bridge Creek."

A chill went up my back, and I wondered whether I had done it right.

The photographs that follow were taken over a period of more than twenty years. I am pleased to say I have seen and photographed much of Glen Canyon National Recreation Area. I am equally pleased that there is much more left to see. "If there is a magic on this planet," wrote Loren Eisley, "it is contained in water." There is still a touch of magic in Glen Canyon.

JOHN TELFORD

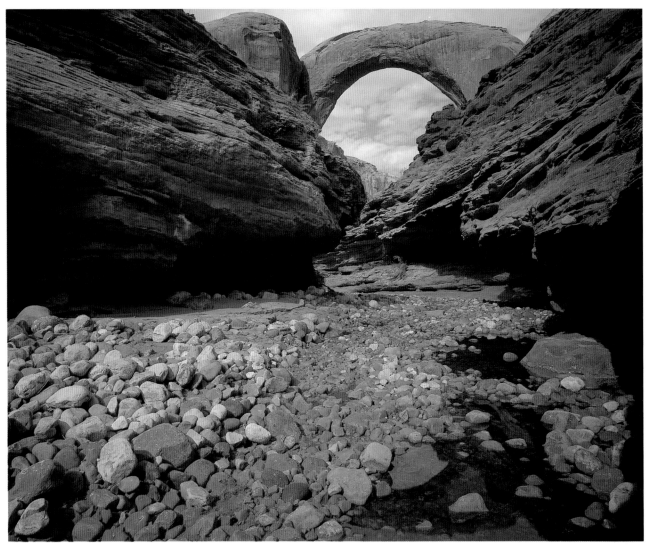

RAINBOW BRIDGE AND BRIDGE CREEK

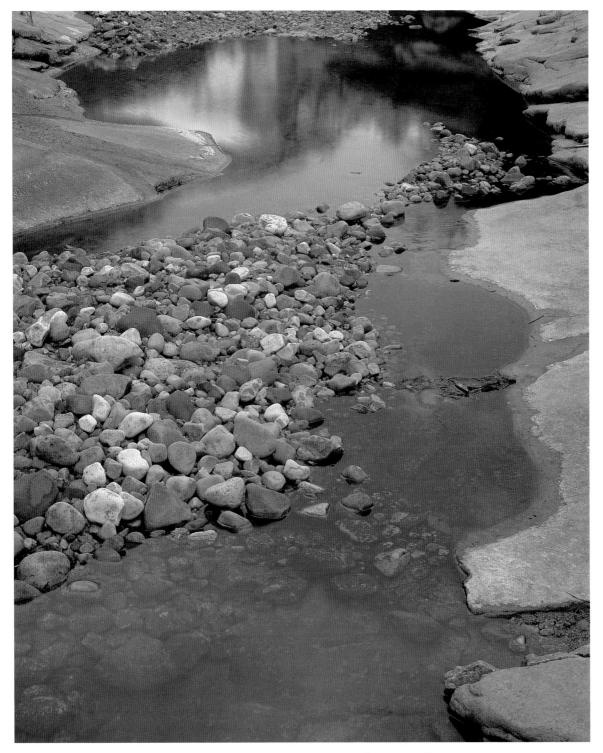

COBBLES AND REFLECTIONS, BRIDGE CREEK

WRITER'S
PREFACE

TWO KINDS OF PEOPLE THINK about Lake Powell: those who regard this marvel of vertical, fissured, domed, arched, and castellated sandstone sandwiched between azure sky and deep blue water as one of earth's treasures and certainly one of its playgrounds. From every continent and every state they come, renting houseboats, buying space on cruise boats, cranking up their own sleek cruisers or outboards. They burn gas, film, and their own skins then return home to afflict friends and family with slide shows and statistics like these:

■ Five million yards of concrete poured nonstop between mid-June 1960 and mid-September 1962 created a dam with a volume of concrete and a height of 783 feet above the river channel that are the second greatest in the Western Hemisphere.

■ When the lake is full, the water is 560 feet deep at the dam face and floods 180 miles up the Colorado River gorge—the world's second largest man-made reservoir.

■ With its two major tributaries, the San Juan and Escalante, and its uncountable coves and inlets, the lake's 1,960-mile coastline is longer than the West Coast's.

■ Three and a half million people a year visit the lake—10,000 at Rainbow Bridge alone on a

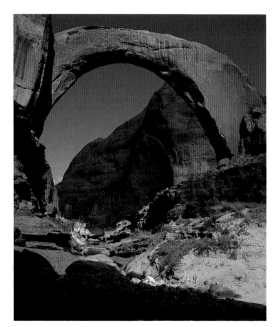

RAINBOW BRIDGE

mid-summer weekend.

■ Storing the Colorado's seasonal runoff puts water on a million acres of Southwest farmland, and the million kilowatts a day turned out by the dam's eight turbines can run the air conditioners and hair dryers of a city of 1.5 million people.

■ Five marinas serve boaters from one end of the lake to the other. One, Dangling Rope Marina at mid-lake, accessible only by boat, pumps 1.8 million gallons of gas a year, the greatest volume of any station in the entire Chevron system.

Then there are those, far fewer, who knew Glen Canyon when the Colorado flowed free

or have read how it was and mourn what is buried beneath those blue waters. They bemoan the eighty-foot bathtub ring left by the subsiding waters, the silt and Russian thistles choking the mouths of side canyons, the increased salinity of water delivered downstream to Mexico, the washing away of beaches and destruction of fish habitat in Grand Canyon by grossly fluctuating water releases from the dam to meet peak power demands in Phoenix and Los Angeles. They point to the inevitability that in time—estimates range from 200 to 500 years—the lake will be silted full, and what we

gained by losing the soul of Glen Canyon will be lost as well.

David Brower, then leading the Sierra Club, laments that the greatest mistake of his life was acceding to the compromise that kept a dam out of Dinosaur National Monument and put one in Glen Canyon instead. He had not seen the canyon before the deal was made, and when he did, it was too late. I am equally guilty. As head of the *Deseret News* editorial page, I wrote editorials supporting the Upper Colorado River Storage Project and sent them to newspaper friends around the country. Not until dynamite was blasting into bedrock did I see the canyon and realize the enormity of our blunder.

So the gates closed, the water rose, and we have what we have, not the magic along and around the floor of Glen Canyon, but a world-famous water playground at a level halfway up its cliffs.

This book, then, is a loving look at the unique

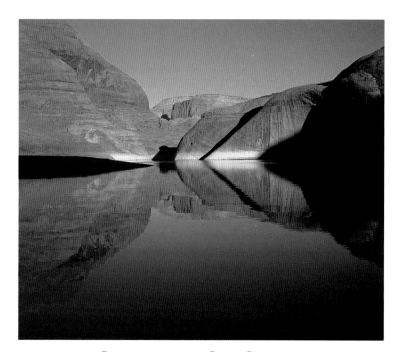

REFLECTIONS, OAK CANYON

marriage of water, rock, and sky through the eyes and soul of a superb nature photographer. It is awe at the aeons and forces that created the canyon country and reverence for the result. It is respect for those who lived in these canyons before and for those who dared the river that flowed here. It is sorrow over what was lost and resolve that we never so offend the earth again. Finally, it is a plea that both its custodians and visitors think more carefully about what they are doing to what is left of Glen Canyon, since the lake is here and won't go away, not within the next half a dozen lifetimes, anyway.

While John Telford's photography may cause readers, as it does me, to despair over their own amateur efforts, it will surely sharpen recognition and appreciation of Glen Canyon's beauty. It's our hope that greater appreciation will bring more thoughtful enjoyment of and care for this special place.

WILLIAM SMART

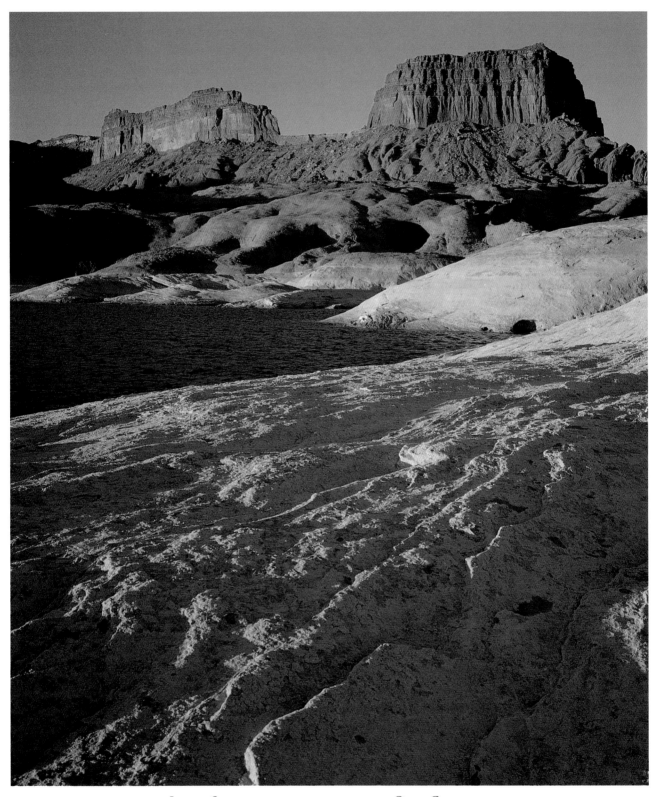

LATE SUNLIGHT, ISLAND NEAR OAK CANYON

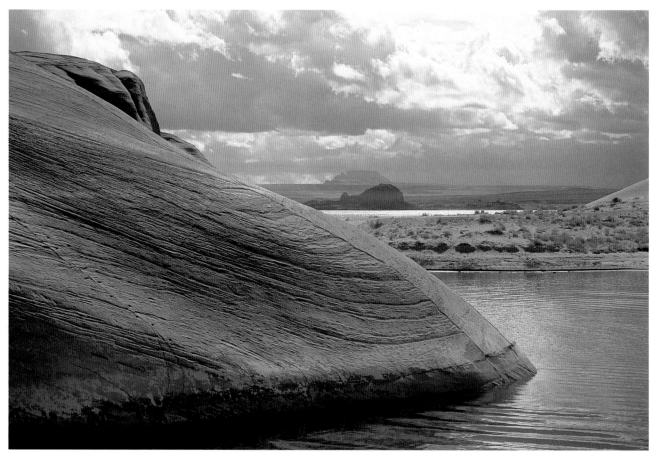

GUNSIGHT CANYON

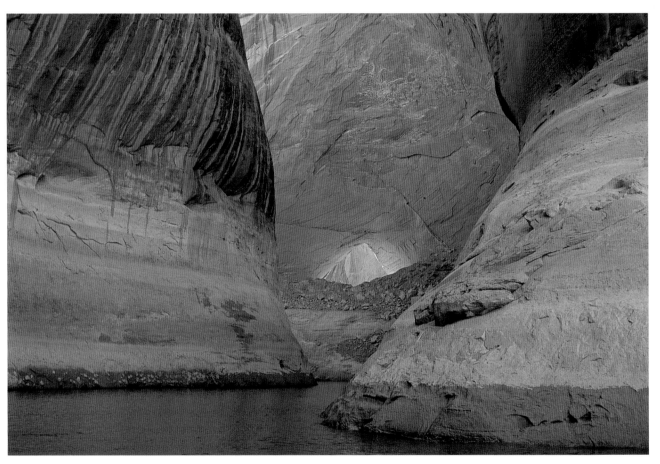

LaGorce Arch, Davis Canyon

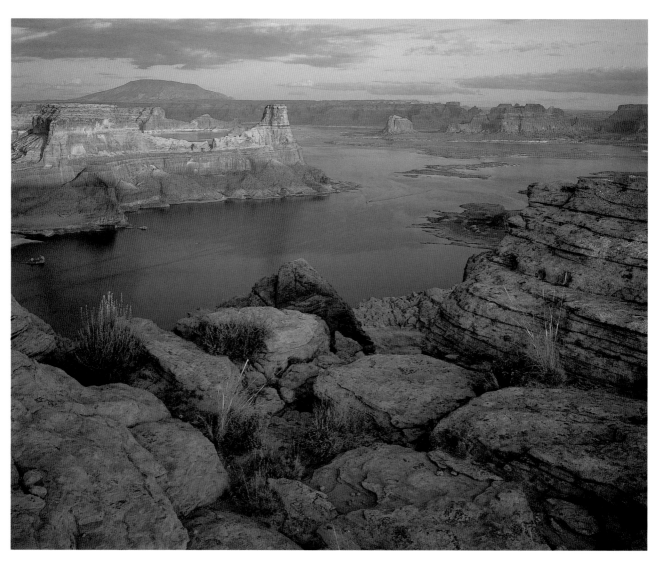

SUNSET, PADRE BAY

THE CREATION

THOSE SHEER CLIFFS, BUFF AND rust-red, knife-edged where great slabs have split off and fallen away. Those arms-width slot canyons, twisting their way through walls hundreds of feet high. Those lovely tapestry walls with alternating stripes of muted colors flowing down the smooth sandstone. Those castles and buttes, fins and spires, pinnacles and balanced rocks. Those cross-bedded frozen sand dunes. That mysterious dome-shaped mountain—Navajo—and, off in the distance, the Henrys and LaSals. How did the Colorado Plateau country get that way?

In the Precambrian era, two billion to half a billion years ago, sedimentary mud hardened into great thicknesses of gneiss and schists. They can't be seen in the Glen Canyon country, but they form the bedrock of the Colorado Plateau. Over them lie limestone layers thousands of feet thick, deposited during the next 300 million years—the Paleozoic era—when the eastern edge of the Pacific Ocean reached this area.

Beginning 200 million years ago in the Jurassic period, the land slowly rose and the ocean drained away. An immense mountain chain grew in Nevada and western Utah, milking the winds of moisture. For 50 million years, winds roared across those mountains, stripping them away and

depositing 2,000-foot sand beds and dunes in the desert that would become the Colorado Plateau. Minerals in water seeping through the sand bound the granules together into the Navajo, Wingate, and other sandstones that form the cliffs, domes, arches, and cross-bedded dunes of Glen Canyon.

By the beginning of the Cretaceous period, 150 million years ago, the Utah/Nevada mountains were gone, and warm winds once again brought moisture. For the next 70 million years, shallow seas advanced and retreated over the area, alternating with lush swamps and tropical forests—the habitat of the dinosaurs and source of the coal deposits in the Kaiparowits Plateau looming above Glen Canyon.

Between the late Cretaceous and early Eocene periods, 80 to 40 million years ago, an eastward shifting of the continental plate produced violent geologic activity that pushed up the Uinta and Rocky Mountains, fracturing and up-tilting the sedimentary rocks. From deep inside the earth, molten magma flowing through faults and cracks in the underlying bedrock raised the massive limestone and sandstone overburdens to great heights. These later eroded away, leaving the igneous domes that became the mountains surrounding Glen Canyon—Navajo, the Henrys, LaSals, and Abajos. Geologists call them laccoliths, these mountains that almost became volcanoes but never quite made it.

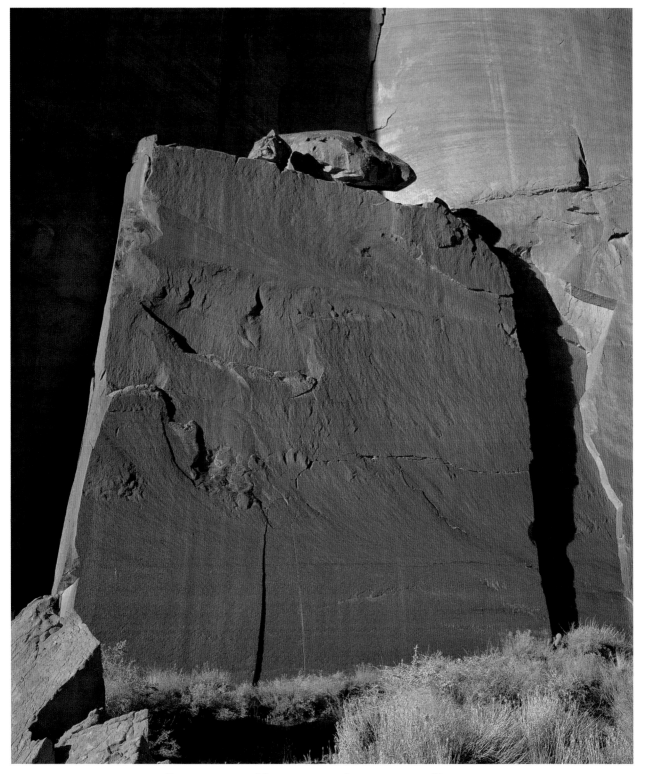

SANDSTONE MONOLITH, LLEWELLYN GULCH

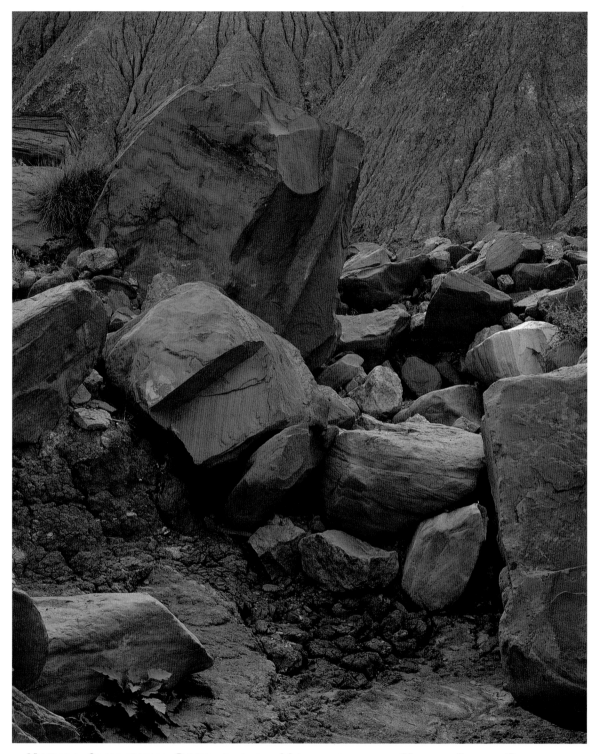

NAVAJO SANDSTONE BOULDERS ON MORRISON CLAY HILLS, PIUTE CANYON

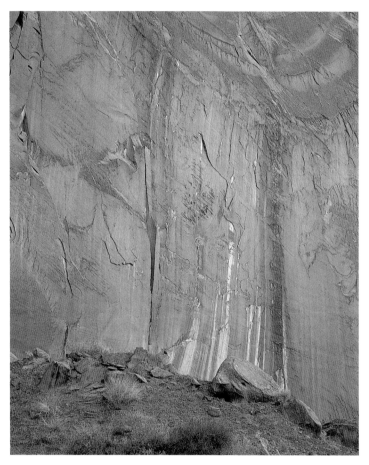

SANDSTONE WALL DETAIL, ESCALANTE CANYON

Aeons passed. Then, 10 to 15 million years ago, another period of continental plate activity pushed up the entire area 10,000 feet above sea level. Meandering rivers became rushing torrents—the Green flowing down from the Wind River Mountains, the Colorado from the central Rockies. They and their tributaries washed away most of the 5,000 feet of Cretaceous depositions and cut deeply into the Jurassic sandstones. Glen Canyon with its myriad side canyons is the result.

Still, the carving and shaping are not finished. Not all sandstone is alike. Some is hard, some soft; some is permeable to water, some not. When underlying softer rock erodes away, the harder sandstone above—usually Navajo in the Glen Canyon region—splits along vertical planes and peels off in great slabs: thus, the masculine vertical cliffs. When water percolating through more porous stone reaches and spreads along an impermeable layer, weakened sections fall away: thus, the domes and arches and alcoves that give such feminine grace to canyon country.

Dripping springs, hidden pools, and hanging

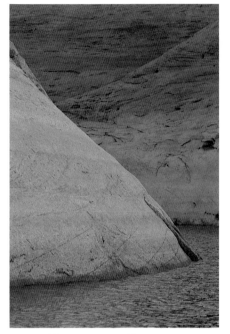

T W I L I G H T C A N Y O N

gardens can be found by hikers in the deep side canyons. How so, in a desert with five inches or so of rain a year? It's the same story of water percolating through sandstone to find an outseep. Where it does, there's magic. In those cool, deeply shaded alcoves, mosses lie thick on the wet cliff face. Maidenhair fern and sedges hang from the seep cracks. Green-blossomed orchids, cave primroses, scarlet monkey flowers, liverwort, and columbines carpet the moist soil below. The keen-eyed hiker may even spot tiny yellow blossoms of the rarest of all Colorado Plateau flowers—the alcove rock daisy.

The flooding of Glen Canyon destroyed countless such places—idyllic spots such as Cathedral in the Desert on the Clear Creek tributary to the Escalante. It's still one of the loveliest spots on the lake, its overarching tapestry walls admitting only a slit of sky overhead. A silent stone sentinel guards the entrance, arms folded inside his blanket, sightless eyes staring at intruders. Those who knew this magical place in pre-dam days can only mourn what was lost.

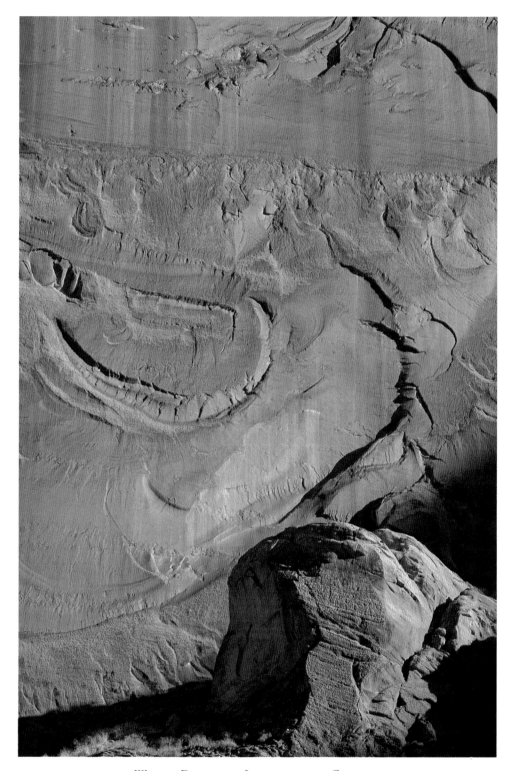

WALL DETAIL, LLEWELLYN GULCH

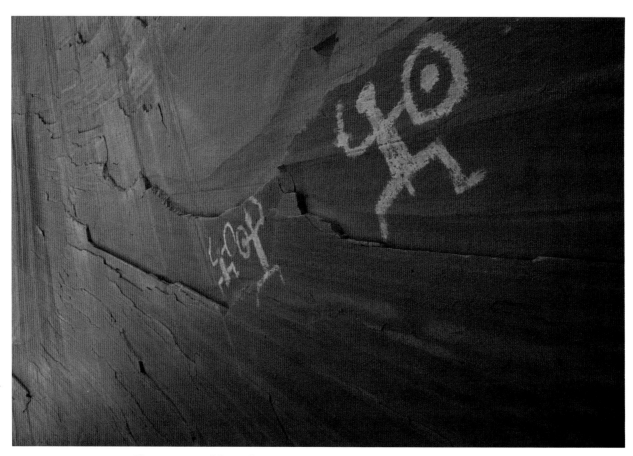

DEFIANCE MAN PICTOGRAPH, FORGOTTEN CANYON

FLOODING DESTROYED MORE than beauty and solitude and adventure. It also drowned almost all remnants of human habitations for a thousand years or more in these canyons. Some traces are left—faint Moki steps pecked into steep sandstone slopes for hands and feet a thousand years dead; a few Anasazi rock structures, granaries mostly, on ledges out of water's reach; a little rock art; steps carved by miners to reach the river or by ranchers to get their cattle down to broad, grassy benches now deep underwater. For canyons as remote and wild as these, a surprising lot happened here with very little left to show for it.

MANKIND
IN THE
CANYON

First to dwell here were the Anasazi, the "Ancient Ones," who disappeared mysteriously 1,300 years ago. Their nomadic ancestors had hunted game and gathered seeds in and out of the canyons for thousands of years as a part of a culture known as Desert Archaic. Around the beginning of the Christian era, the Anasazi began primitive farming, raising corn and squash. That meant permanent homes in caves or crude pit houses. By around A.D. 700 a more advanced culture evolved. Pottery replaced basketmaking, stone masonry replaced the pit houses, and the bow and arrow replaced the atlatl or throwing stick. About this time, the

Anasazi began building masonry homes in the deep canyons of the Colorado and San Juan.

John Wesley Powell, the first man known to have run the Green and Colorado to the bottom of Grand Canyon, saw, almost as soon as he entered Glen Canyon, remnants of that occupation:

We enter a canyon today, with low, red walls. A short distance below its head we discover the ruins of an old building on the left wall . . . Its walls are of stone, laid in mortar with much regularity. It was probably built three stories high . . . Great quantities of flint chips are found on the rocks near by, and many arrowheads, some perfect, others broken; and fragments of pottery are strewn about in great profusion. On the face of the cliff, under the building and *along down the river for 200 or 300 yards, there are many etchings [petroglyphs].*

Fifteen miles downstream he found another group of buildings, one with five rooms on the ground floor and a kiva. Before the day was out, he had climbed the cliffs, using Moki steps and an ancient ladder, to reach what he took to be an Anasazi watch tower. After that, probably because they were so common, he mentioned no more Anasazi dwellings.

But other scholars do. For seven summers, racing the dam builders, archaeologists and historians from the University of Utah and Museum of Northern Arizona painstakingly recorded 2,500 Anasazi sites in Glen Canyon. The Ancient Ones

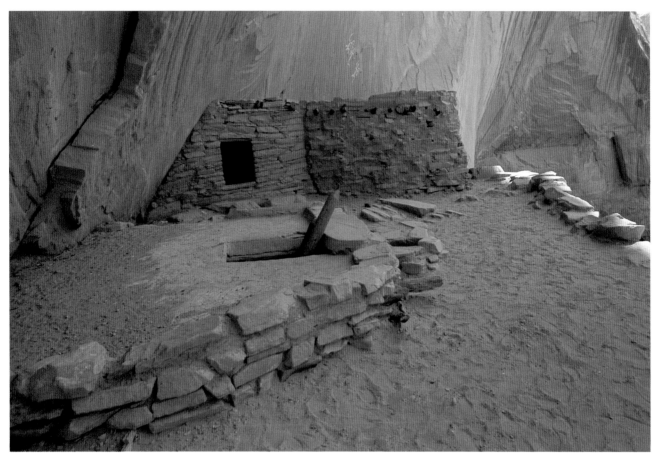

DEFIANCE HOUSE RUIN, FORGOTTEN CANYON

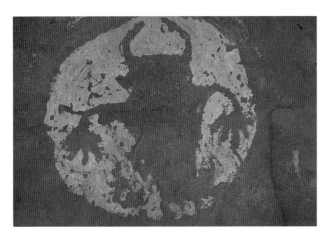

PICTOGRAPH, DAVIS CANYON
(destroyed by flooding)

INSIDE RESTORED RUIN,
ESCALANTE CANYON

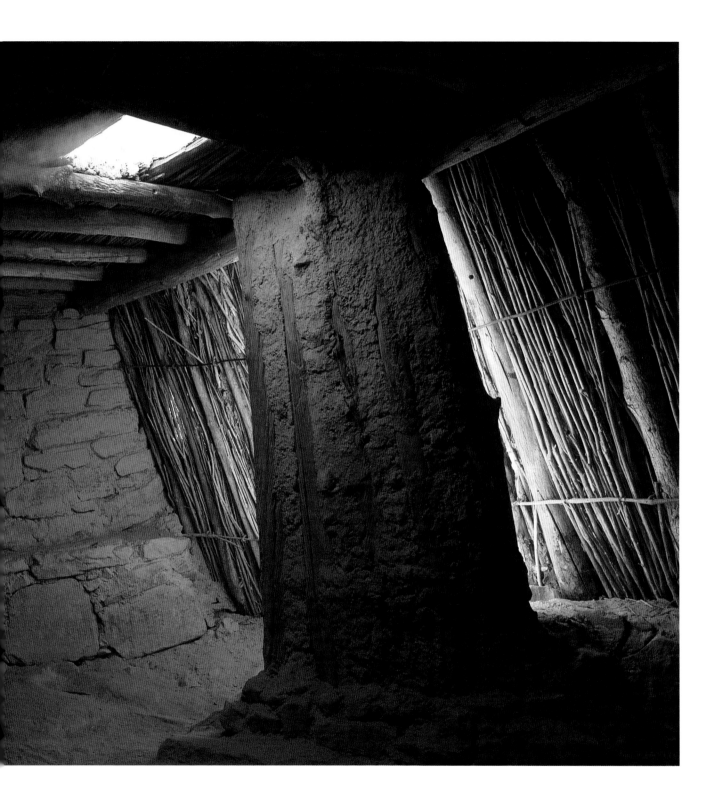

were artists; they left exquisite panels of petroglyphs and pictographs of animals, birds, human figures, and mysterious geometric designs. They were also engineers; the scholars unearthed remnants of astonishingly sophisticated irrigation systems—in one place, for example, a masonry dam with a control gate and stone-lined ditch to carry water to stone-terraced fields.

Only pitiful traces of that culture remain above water. On a recent trip, we scrambled up a steep slope in the Escalante arm to a small structure and kiva the Park Service had "restored." The roof was plywood, and rusting rebar held the posts together, a wretched job. Even the splendid rock-art panel that was supposed to stay above high water in Davis Gulch is gone. Holding her nose, my wife once spent an hour collecting and burning toilet paper there, and vowed never to return. She needn't, and neither need anyone else. Incompetent dam management let the lake rise seven feet above capacity during the flood years of the early eighties, and, as evidence of the superiority of our civilization, a bathtub ring overlays the art.

After the Anasazi disappeared, probably because of drought, occasional bands of Paiutes and, later, of Utes wandered around and into the canyon; one route down the cliffs and across the river was well enough traveled it later became

known as Ute Crossing. It was to this place that Indians along the Virgin River directed the party that would become the first white men ever to enter Glen Canyon.

In July 1776, Fray Francisco Atanasio Dominguez and Fray Silvestre Velez de Escalante set out with eight companions from Santa Fe seeking a route to the Spanish missions in California. Avoiding the waterless wastes and hostile Indians of Arizona, they went north through western Colorado to northeastern Utah, then southwest in a long diagonal route through the state. Along the way, they realized winter was catching them and their chances of reaching California were slim or none. They headed for home by what they thought was the shortest route. At a camp southeast of present-day St. George, Indians pointed them east toward the known ford of the Colorado.

Suspicious of that advice, the fathers went south instead. It was a mistake. After ten days of wandering through the Arizona Strip, concluding that the country was too rough and that they couldn't cross the Grand Canyon even if they could get to it, they finally reached the Colorado at the mouth of the Paria River. This is twenty miles downstream from Glen Canyon Dam, the place where John D. Lee, hiding away after his part in the Mountain Meadows Massacre, would later

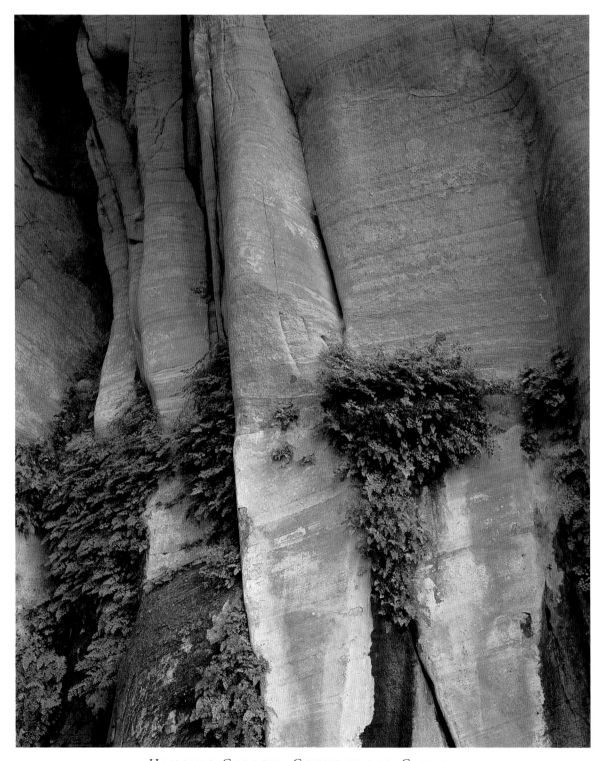

HANGING GARDEN, COTTONWOOD CANYON

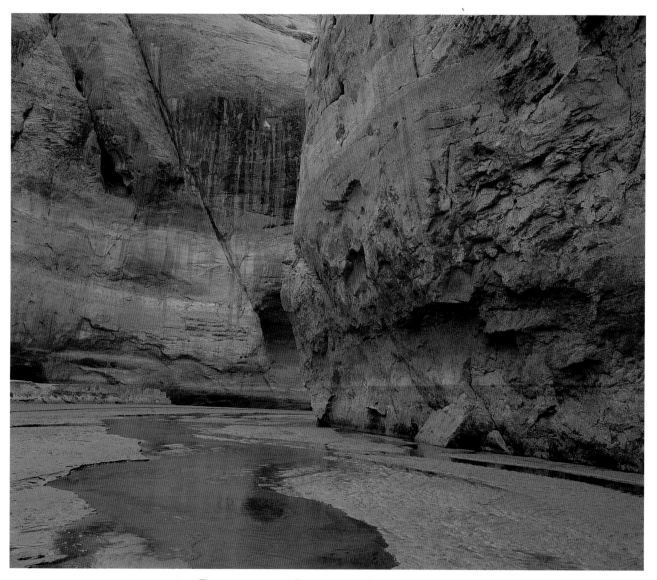

FORBIDDING CANYON, STREAM SILT

build a ferry. River runners launch there today for the 230-mile adventure through Marble and Grand canyons.

For Escalante and his companions, there was no ferry and no whitewater raft. They spent four days trying to get out of that place. With clothes bundled on their heads, the party's two best swimmers tried to cross and explore a way out on the other side. The current was too deep and too strong; they returned shoeless and naked. They tried a raft, but fifteen-foot poles couldn't reach the bottom. One man explored up the Paria a day and a half and found no way out. Others tried upriver along the banks but found, Escalante wrote, "insuperable obstacles." No wonder they named this place Salsipuedes—get out if you can.

But get out they did, scrambling up "extremely difficult stretches and most dangerous ledges." Moving north along the cliff tops, they camped that night 1,700 feet above the river, looking down at what is now the Wahweap Resort. Five more days they struggled "over many ridges and gullies," looking for a ford and a way down to it. They ate

WALL DETAIL, ESCALANTE RIVER
AT STEVENS CANYON

the last of a horse slaughtered at Salsipuedes and killed another, roasted prickly pear cactus, drank rainwater collected in rock depressions, and suffered bitterly in "a strong blizzard and tempest consisting of rain and thick hailstones amid horrendous thunder claps and lightning flashes"—November conditions to which more than a few Lake Powell bass fishermen can relate.

At last, they found the ford and a way down Padre Creek, now Padre Bay, cutting steps in the stone at one place to let the horses descend. They lowered packs and saddles down the cliff with ropes, crossed the river in waist-deep water, and celebrated by "firing off some muskets in demonstration of the great joy we all felt in having overcome so great a problem."

Tower Butte today marks the Crossing of the Fathers on one side of the lake, Boundary Butte (on the Utah-Arizona state line) their exit on the other side. The steps they chopped for horses' feet going down are deep underwater. So are those they chopped climbing out the other side, up Labyrinth Canyon, where, two hundred years later, another

religious epic was staged, the filming of *The Greatest Story Ever Told,* with Charlton Heston as John the Baptist. But if the steps are drowned, other marks of passage in the stone remain—gouges and prop marks along tops of once-submerged buttes where incautious drivers lost a prop or perhaps the bottom of a boat.

Almost a century passed before the next travelers of note penetrated these canyons. On May 24, 1869, ten unlikely explorers—a one-armed Civil War veteran and various ex-soldiers and trappers—pushed four overloaded, poorly designed boats into the current where the railroad crossed the Green River in Wyoming. They knew nothing of white-water boat-ing or of the thousand miles of canyon ahead—only rumors of cataracts and falls, boat-swallowing whirlpools, places where the river dove under-ground. It wasn't quite like that, but the rapids of Lodore, Cataract, Marble, and, finally, Grand Canyon were bad enough. Only two boats and six men finally spilled out the bottom of Grand Canyon ninety-six days later. One man defected early. Three others, terrorized by Lava Falls and fearful of what might lie ahead, quit and climbed out to the north, only to be killed by Indians atop the plateau. Their departure was just two days

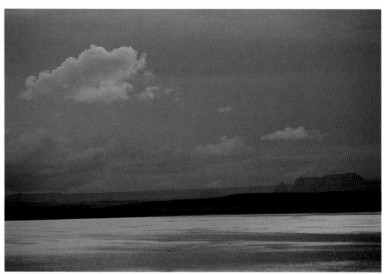

WAHWEAP BAY

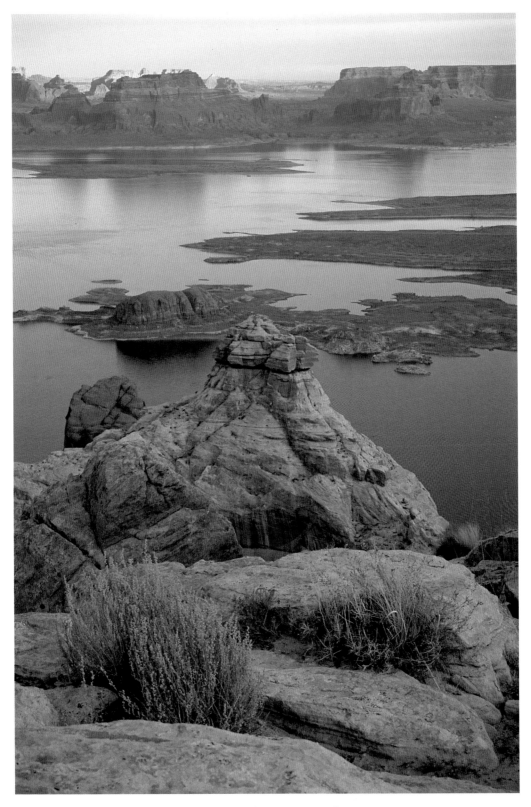

PADRE BAY, AHLSTROM POINT

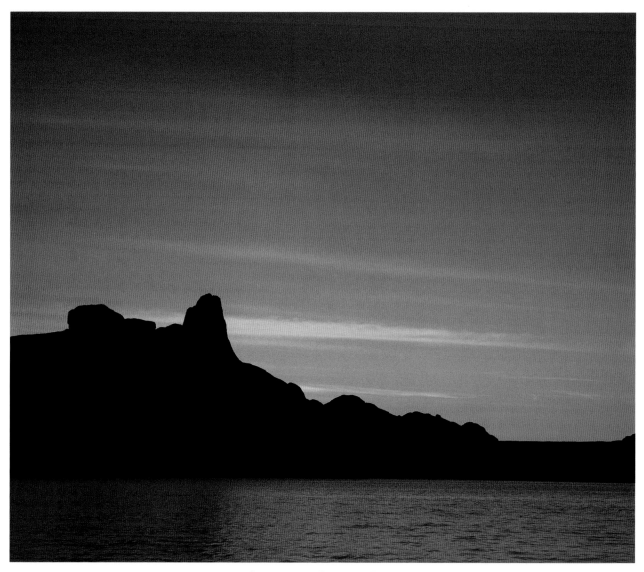

SUNRISE, PADRE BAY

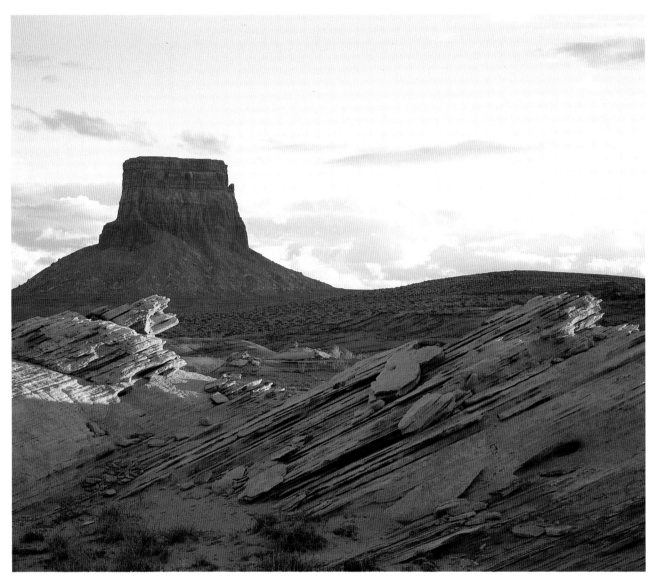

TOWER BUTTE, LABYRINTH CANYON

before the others emerged from the canyon to safety.

This first trip of John Wesley Powell down the Green and Colorado was one of this country's great adventure epics. It and his expeditions in the next ten years did more to discover the shape and character of the Colorado Plateau than any exploration before or since. His 1872 overland survey, for example, put on the maps for the first time the Escalante River and Henry Mountains, the last-discovered river and mountains in the continental United States.

But it is what Powell saw and described in Glen Canyon that concerns us here. To him, between the terrors of Cataract Canyon and those to come in Marble and the Grand, it was seven

idyllic days of safety and beauty.

"The sandstone, through which the canyon is cut, is red and homogeneous," Powell wrote. Sandstone, being soft, creates no rapids; there were none in Glen Canyon. And so,

July 30—We make good progress today, as the water, though smooth, is swift. Sometimes, the canyon walls are vertical to the top; sometimes, they are vertical below, and have a mound-covered slope above . . . In the deep recesses of the walls, we find springs, with mosses and ferns on the moistened sandstone.

July 31—We have a cool, pleasant ride today . . . The walls are steadily increasing in altitude, the curves are gentle, and often the river sweeps by an arc of vertical walls, smooth and unbroken, and then by

a curve that is variegated by royal arches, mossy alcoves, deep, beautiful glens, and painted grottoes.

Soon after dinner, we discover the mouth of the San Juan, where we camp . . .

August 1 . . . We find ourselves in a vast chamber, carved out of the rock. At the upper end there is a clear, deep pool of water, bordered with verdure . . . The chamber is more than two hundred feet high, five hundred feet long, and two hundred feet wide. Through the ceiling, and on through the rocks for a thousand feet above, there is a narrow, winding sky-light; and this is all carved out by a little stream, which only runs during the few showers that fall now and then in this arid country . . . We are pleased to find that this hollow in the rocks is filled with sweet

sounds. It was doubtless made for an academy of music by its storm-born architect; so we name it Music Temple . . .

August 3 [after an extra day at Music Temple] . . . Other wonderful features are the many side canyons or gorges that we pass. Sometimes, we stop to explore these for a short distance. In some places, their walls are much nearer each other above than below, so that they look somewhat like caves or chambers in the rocks. Usually, in going up such a gorge, we find beautiful vegetation; but our way is often cut off by deep basins, or potholes, as they are called.

On the walls, and back many miles into the country, numbers of monument-shaped buttes are observed. So we have a curious ensemble of wonderful

features—carved walls, royal arches, glens, alcoves, gulches, mounds, and monuments. From which of these features shall we select a name? We decide to call it Glen Canyon.

Past these towering monuments, past these mounded billows of orange sandstone, past these oak-set glens, past these fern-decked alcoves, past these mural curves, we glide hour after hour, stopping now and then, as our attention is arrested by some new wonder . . .

That's Glen Canyon before the dam. What has happened since is a debatable tradeoff. Pre-dam, a few hundred adventurers drifted through the canyon each year on inner tubes, drugstore rafts, or anything that floats. Is it worth sacrificing that kind of experience for the kilowatts the dam generates plus the opportunity for 10,000 people to stand under Rainbow Bridge on a summer weekend?

Ten years after Powell and his crew floated serenely through Glen Canyon, another band of pioneers saw it in a different light. These were the men and women who hacked out and then descended that fearful gash in the cliffs just down

MAIDENHAIR FERN,
NEAR RAINBOW BRIDGE

lake from the Escalante—the place called Hole-in-the-Rock.

In the late 1870s, Brigham Young's colonizing zeal had planted Mormon settlements in every fertile valley west of the high plateaus bisecting Utah. However, east of that line, except for a tiny settlement called Potato Valley, later Escalante, Utah was empty. East of the Colorado River, in fact, even the maps were empty; it was unknown territory. Young resolved to change that by planting a Mormon outpost in the far southeast corner of Utah, on the San Juan River. It would help control the Indians who were crossing the Colorado to raid Mormon settlements, he reasoned, and keep out the New Mexican and Texas cow outfits that were beginning to push into the country.

By November 1879, the colonizers were ready to go—250 men, women, and children, 82 wagons, more than 1,000 head of livestock. One route to the San Juan, through northern Arizona, had been judged too dry and too aggravating to the Indians; another, looping north along the Old Spanish

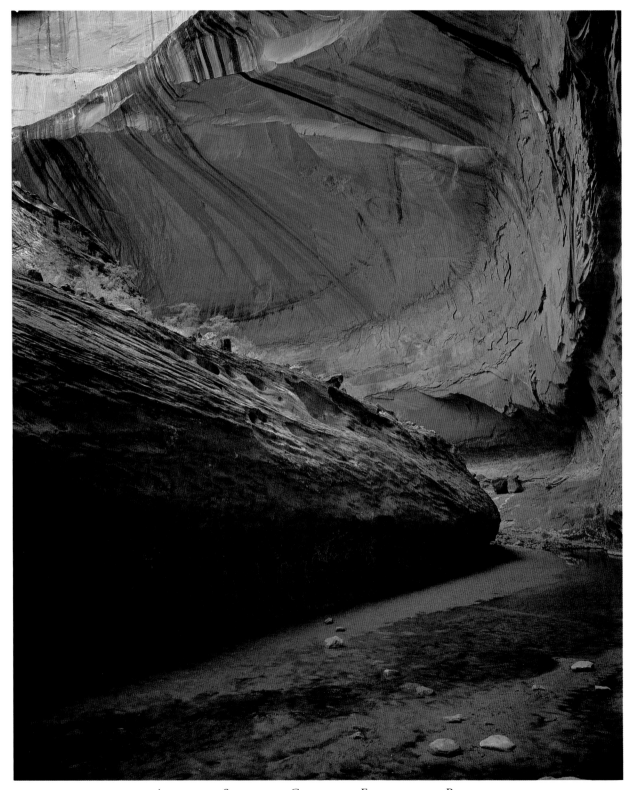

ALCOVE, STEVENS CANYON, ESCALANTE RIVER

Trail, too long. Either would have taken, at most, eight weeks. Instead, with the sketchiest kind of advance exploration, the colonizers headed straight toward their destination, finally getting there only after six months of risk and toil through the roughest country ever to see a wagon road.

Building an eighty-mile road from Escalante below the Kaiparowits Plateau to the Colorado took a month of grinding labor. By the time they reached the rim of Glen Canyon, 2,000 feet above the river, snow lay deep in the mountains behind them. Though scouts reported that the country beyond the Colorado was impassable for wagons, they could only go on. Six weeks in numbing cold they labored at the rim. They chopped out a forty-

foot, wagon-wide notch through the rimrock. They stitched a road along the cliff side by driving scrub-oak stakes into holes drilled two feet apart, laying cottonwood poles across the stakes and piling up rocks and dirt to support the wheels. "Uncle Ben's Dugway" they called that part of the road, after Ben Perkins, the Welsh miner who designed it. With twenty men holding back on ropes with all their strength, his wagon was given the honor to be the first down—to see if his creation would hold. It did, and for eighty-one other wagons to follow.

Thousands of boaters idle their motors to stare up the Hole—some even climb up there—marveling that anyone could be so courageous and ingenious, or pig-headed, as to attempt such a thing. They

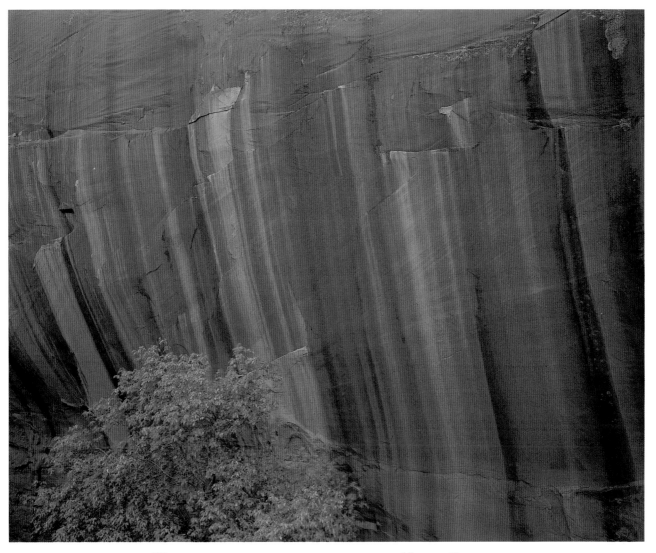

WALL DETAIL AND COTTONWOOD, NEON CANYON

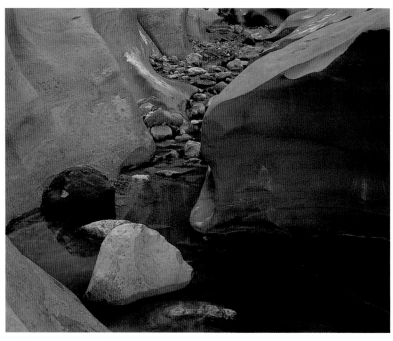

CHOPROCK CANYON, STREAM BED WITH BOULDERS

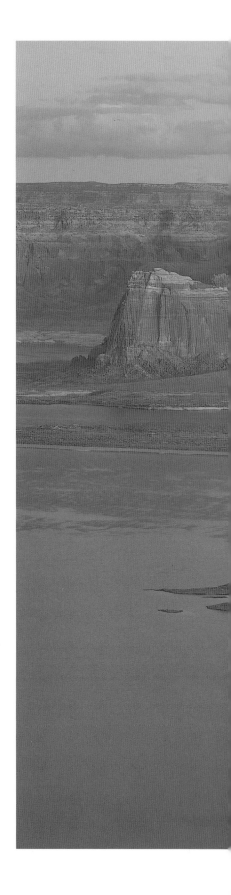

SUNSET, AHLSTROM POINT
AND ROMANO MESA

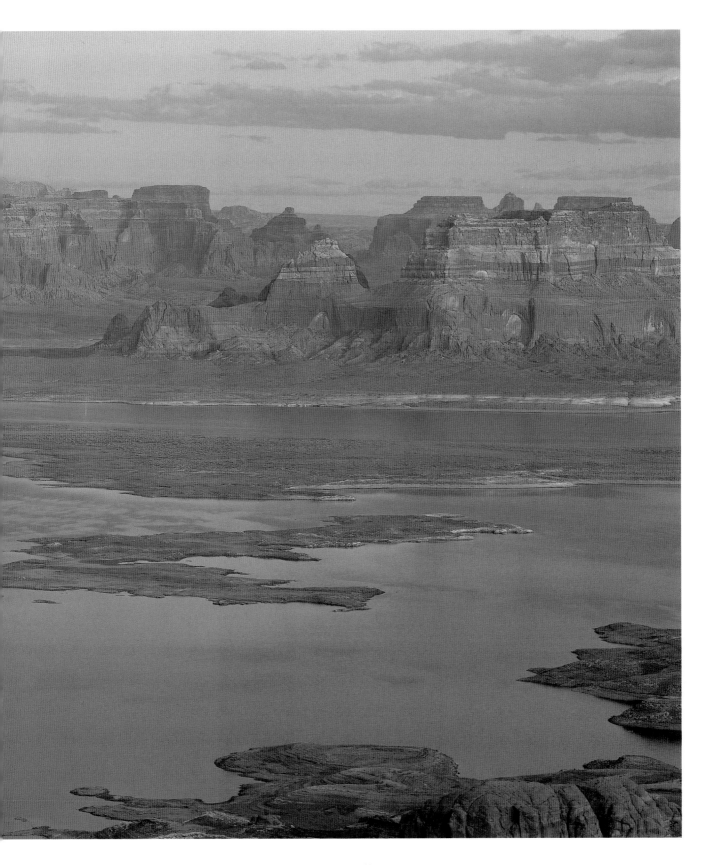

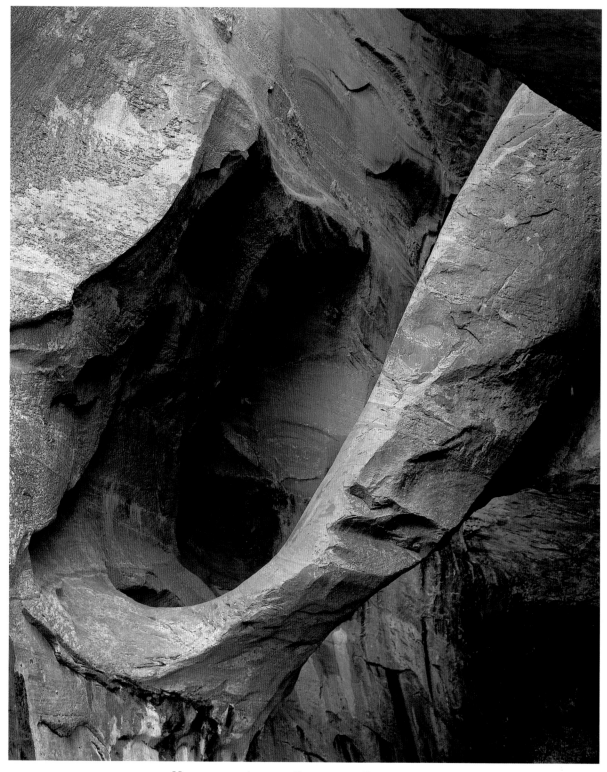

HANGING ARCH, STEVENS CANYON

would marvel more if they took the longer hike out the other side to the head of Cottonwood Canyon, where the Hole-in-the-Rock pioneers confronted a similar cliff, and where in another Uncle Ben's Dugway, the stakes are still in place.

Of all the accounts of the ordeal at the Hole, none captures its essence more than one based on the memoirs of Joseph Stanford Smith, written by his grandson and published in *Desert Magazine* (June 1954). All day long Smith had labored to help other wagons down the Hole and the perilous trail below. At day's end, he climbed back to the rim for his own wagon, his wife and three small children. Other men, not realizing there was a last wagon up there, had left. The Smiths were alone.

Hooking up the team, with one horse tied to the rear axle, Smith cross-chained the wheels. Then

. . . they walked to the top of the crevice, where hand in hand they looked down—ten feet of loose sand, then a rocky pitch as steep as the roof of a house and barely as wide as the wagon. Below that a dizzy chute down to the landing place, once fairly level but now ploughed up with wheels and hooves. Below that they could not see, but Stanford knew what was down there—boulders, washouts, dugways like narrow shelves. But it was that first drop of 150 feet that scared him.

"I'm afraid we can't make it," he exclaimed.

"But we've got to make it," she answered calmly.

They went back to the wagon where Stanford

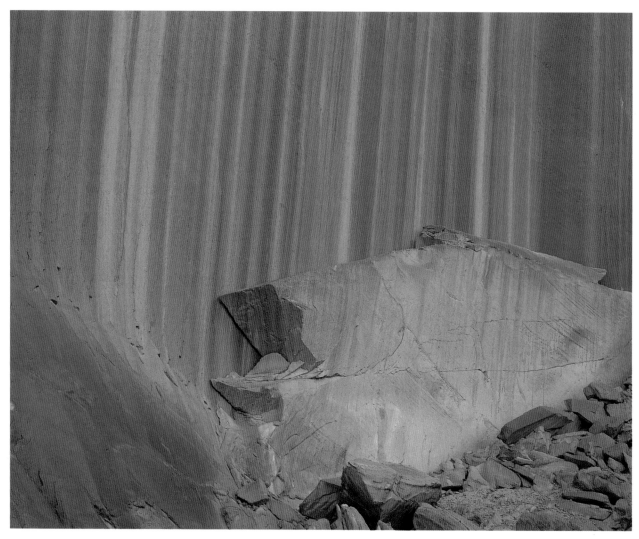

WALL DETAIL, COTTONWOOD CANYON

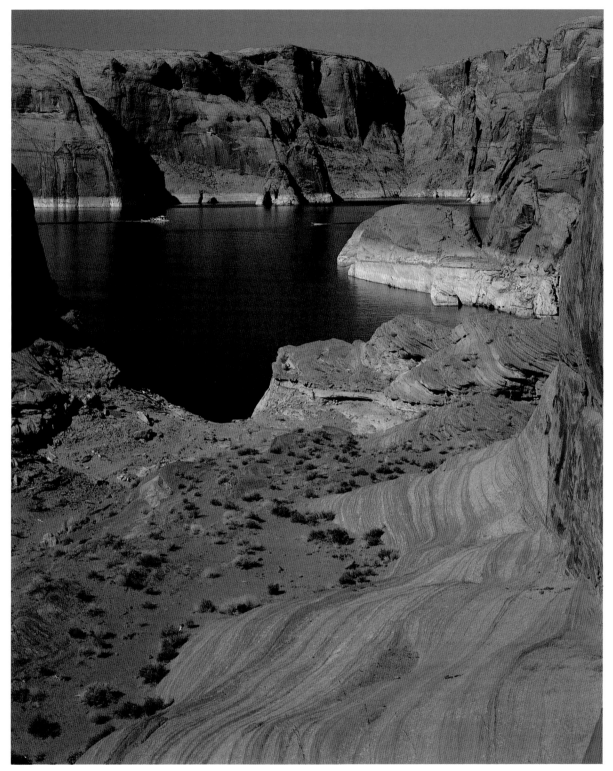

H O L E I N T H E R O C K

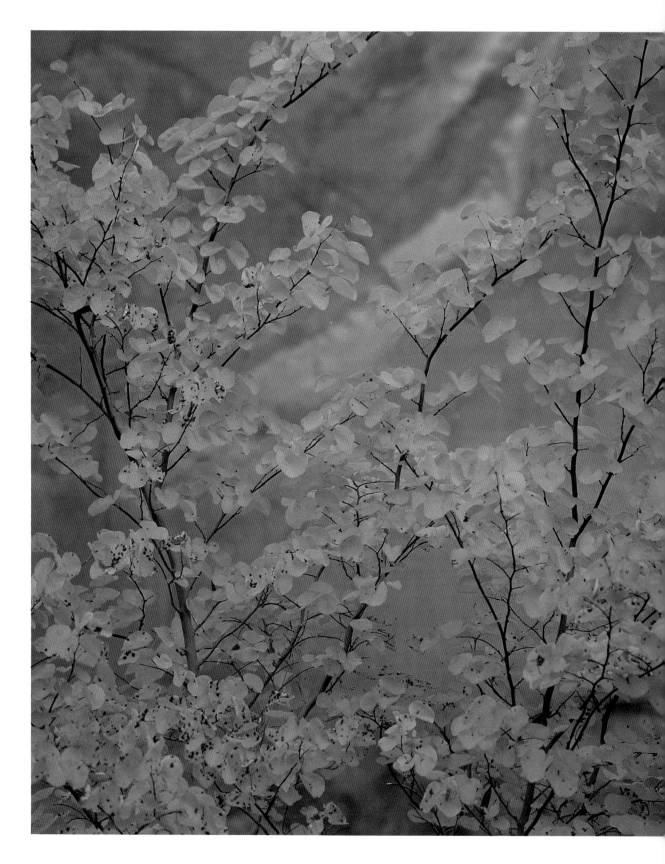

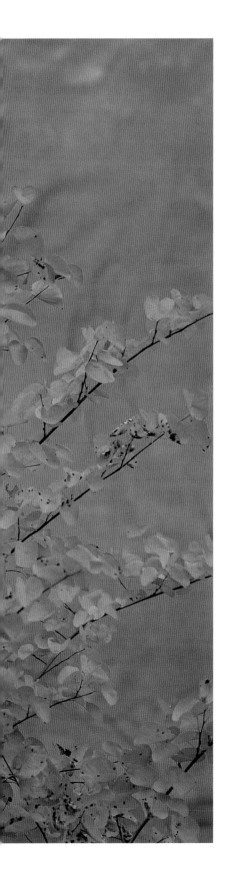

checked the harness, the axles, the tires, the brakes. He looked at Belle, and felt a surge of admiration for this brave, beautiful girl. They had been called to go to San Juan, and they would go. With such a wife, no man could retreat.

"If only we had a few men to hold the wagon back we might make it."

"I'll do the holding back," said Belle, "on old Nig's lines. Isn't that what he's tied back there for?"

"Any man with sense in his head wouldn't let a woman do that."

"What else is there to do?"

"But, Belle, the children?"

"They will have to stay up here. We'll come back for them."

"And if we don't come back?"

"We'll come back. We've got to . . ."

Stanford braced his legs against the dashboard and they started down Hole-in-the-Rock. The first lurch nearly pulled Belle off her feet. She dug her heels in to hold her balance. Old Nig was thrown to his haunches. Arabella raced after him and the wagon, holding to the lines with desperate strength. Nig rolled to his side and gave a shrill neigh of terror. His dead weight will be as good as a live one, she thought.

Her foot caught between two rocks. She kicked it free but lost her balance and went sprawling after old Nig. She was blinded by the sand which streamed

after her. She gritted her teeth and hung on to the lines. A jagged rock tore her flesh, and hot pain ran up her leg from heel to hip. The wagon struck a huge boulder. The impact jerked her to her feet and flung her against the side of the cliff. The wagon stopped with the team wedged under the tongue. Stanford leaped to the ground and loosened the tugs to free the team, then turned to Arabella. There she stood, her face white against the red sandstone.

He used to tell us she was the most gallant thing he had ever seen as she stood there, defiant, blood-smeared, begrimed and, with her eyes flashing, dared him to sympathize.

In a shaky voice he asked, "How did you make it, Belle?"

"Oh, I crow-hopped right along," she answered. He looked away . . .

Stanford looked up the crack. Up there on the sharp rocks a hundred feet above him waved a piece of white cloth, a piece of her garment. Why, she had been dragged all that way!

"Looks like you lost your handkerchief, Belle." He tried to force a laugh, instead choked and grabbed her to him, his eyes going swiftly over her. A trickle of blood ran down her leg, making a pool on the rocks.

"Belle, you're hurt! And we're alone here."

"Old Nig dragged me all the way down." she admitted.

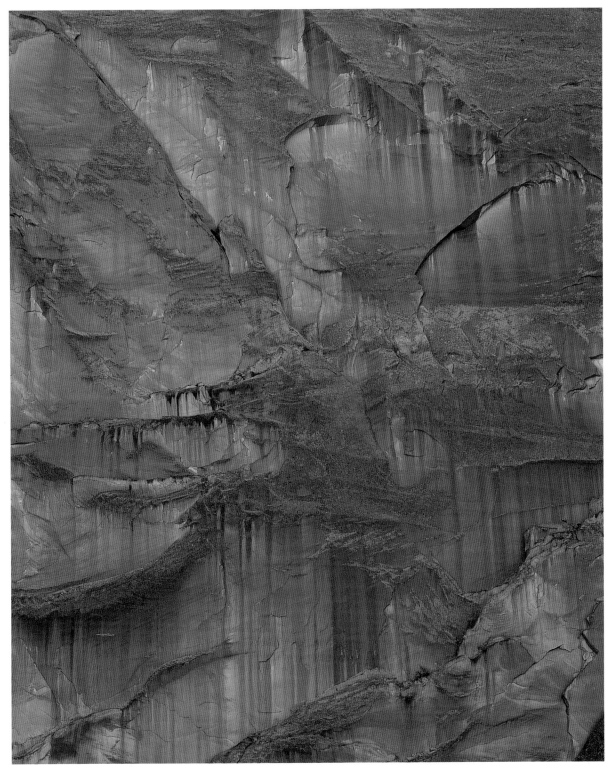

WALL DETAIL, COYOTE CANYON

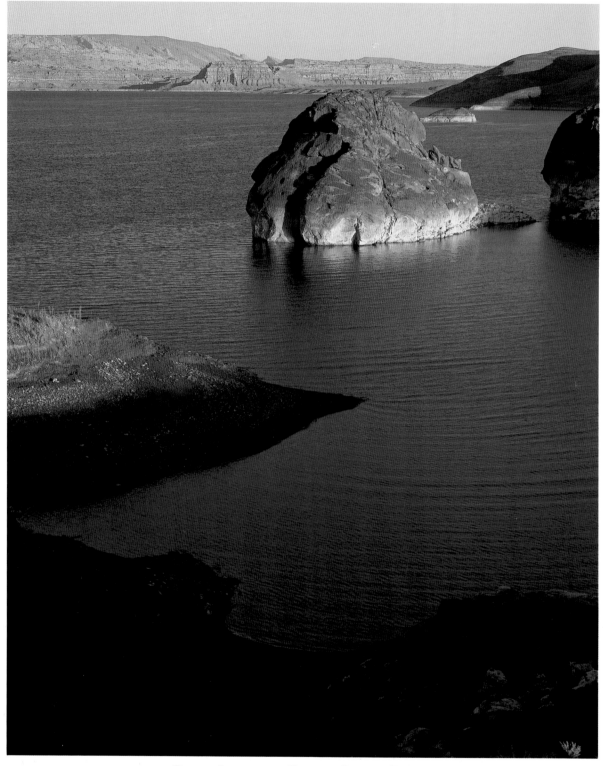

ROCK ISLANDS, HALLS CREEK BAY

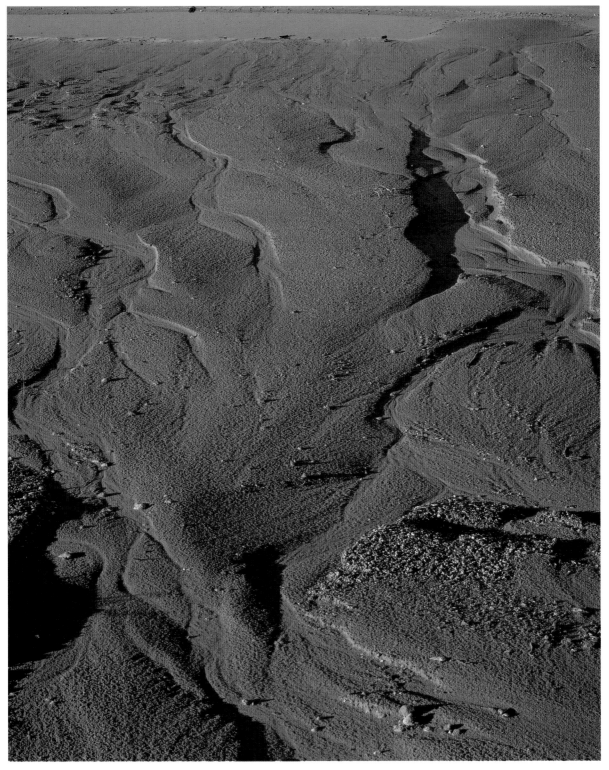

Sᴀɴᴅ ʀɪғғʟᴇs, Hᴀʟʟs Cʀᴇᴇᴋ Bᴀʏ

"Is your leg broken?" he faltered.

She wouldn't have his sympathy; not just yet, anyway. "Does that feel like it's broken?" she fairly screamed, and kicked his shin with fury.

He felt like shaking her, but her chin began quivering and he had to grin, knowing by her temper she wasn't too badly hurt. He put his arms around her and both began crying, then laughing with relief.

They had done it! Had taken the last wagon down—alone!

Incredibly, others took wagons down and up that route for the next couple of years, using a ferry Charles Hall had built at the site to help get the Hole wagons across the river. He soon moved his ferry to a more likely approach to the river, at the mouth of Halls Creek thirty-five miles upstream. His operation there was doomed two years later when a Colorado prospector named Cass Hite found placer gold forty-five more miles upriver, at a place he called a "dandy crossing."

At first, it was gold fever rather than a ferry site that brought traffic there. Within six years of Hite's discovery in 1883, no fewer than 1,000 prospectors were sluicing the Glen Canyon river bars. Most of them floated down from Dandy Crossing, which quickly became Hite, the only town on the river between Moab and the Mormon settlement of Callville, 600 river miles downstream.

Finding the gold wasn't hard; it lay in sand and gravel bars all along Glen Canyon. Getting it out

was another matter. Placer machinery wasn't designed to separate flour gold that fine. Besides, the Colorado's heavy load of silt quickly wore out the pumps, and hacking steps up the sheer cliffs for mules to haul supplies in and gold, if any, out was no picnic. In the end, the returns didn't justify the effort; by 1910 the gold rush was over.

In his six-year pre-flooding project of documenting human activity in the canyon, C. Gregory Crampton found much evidence of those blasted hopes. At Klondike Bar, opposite Aztec Canyon, he found scrapers, ore trucks, flumes, and sluice boxes. At Gretchen Bar, five miles downstream from Lake Canyon, more of the same, plus hydraulic nozzles, an ancient tractor, and a well-

preserved rock cabin. At Moqui Bar, Smith Bar, California Bar, Olympia Bar, Good Hope Bar, Ticaboo, all upstream from Halls Crossing, still more detritus of the passion for gold, including ingeniously built waterwheels to lift river water to the sluice boxes.

Today's ferry from Bullfrog to Halls Crossing passes near the drowned remains of the most ambitious project of all, Robert Brewster Stanton's folly, his second one. In 1889, Stanton floated the river as engineer for the newly formed Denver, Colorado Canyon and Pacific Railroad Company, surveying for a river-level rail route through the canyons to California. There were no life jackets among the eighteen-man party; Frank M. Brown,

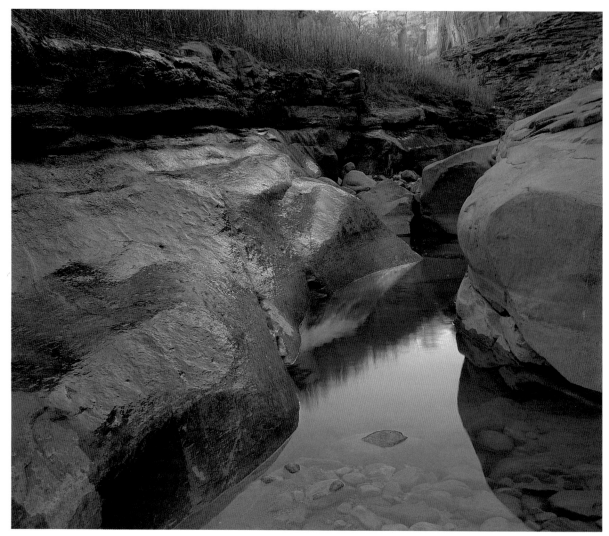

POOL, BRIDGE CREEK

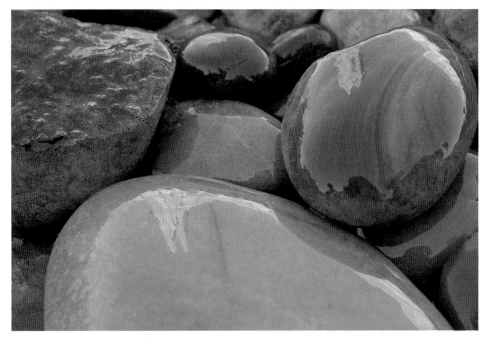

REFLECTION ON BLUE ROCKS

the company president, had insisted they weren't
needed. He paid for that machismo by drowning
in Marble Canyon, as did two other men who died
trying to save him. But Stanton made it through
and returned convinced that the railroad was
feasible. Fortunately, sanity pre-
vailed in the financial community,
and he never raised the money.

Still, he had other ideas. Float-
ing through Glen Canyon, Stanton
saw the gold-mining efforts there
and decided he needed only an
efficient large-scale operation to
make a fortune. Hauling parts 100
miles by wagon from the railroad at
Green River and cutting a dugway

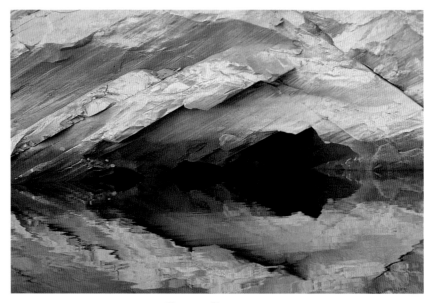

FACE CANYON

down the cliffs, his Hoskannini Mining Company
assembled a 105-foot, 46-bucket gold dredge on
the river. After spending $100,000, the company
reported recovery of $30.15 in gold in one
cleanup, $36.80 in the next—about the going rate
of return in the Glen Canyon Gold Rush. The
story goes that on a 1938 recreational river trip,
Julius Stone, once the Hoskannini Company presi-
dent, ripped some boards off the abandoned
dredge, built a fire, and brewed what he called a
$5,000 cup of coffee.

Though Stone's search for gold didn't pan out,

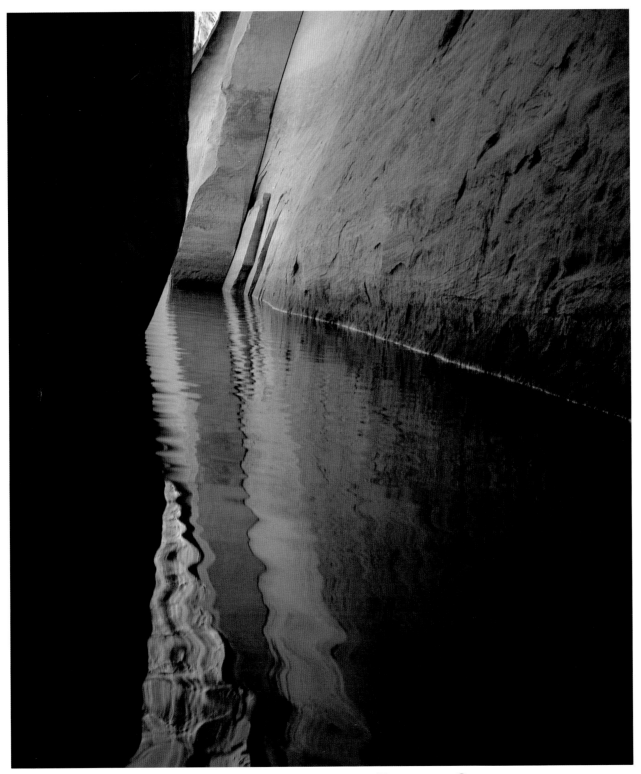

REFLECTIONS AND WALL DETAIL, TWILIGHT CANYON

he began another kind of search in Glen Canyon that continues today. The Hoskannini dream was only seven years dead when, in 1909, he hired a river runner/trapper named Nathaniel Galloway to take him down the Green and Colorado on the first trip with no other purpose than adventure, beauty, and renewal. By this time, Stone had his priorities straight. With neither gold dredges in the river nor a railroad along its banks despoiling the wilderness, he was able to write:

Here [in Glen Canyon] where the world is shut out, the spirit of the wilderness still abides and welcomes one into the full freedom and magic of the night and morning; uplifting and swaying the beholder with a sense of being that is delightful past compare.

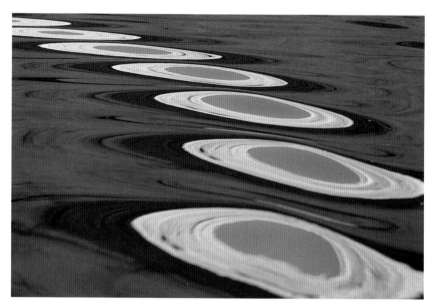

REFLECTIONS ON WATER

Others caught on. Ellsworth and Emery Kolb floated the canyons in 1911, taking movie footage they would show for the next fifty years at the South Rim of Grand Canyon. Bert Loper abandoned his cabin and diggings at the mouth of Red Canyon in 1915 and spent the rest of a long life as a river runner until 1949. Then he died alone, probably from a heart attack, running a rapid in

Marble Canyon. Forty-nine was a bad year. Norman Nevilles died with his wife that year when their small plane crashed on takeoff from the Mexican Hat airstrip, ending eleven years as the first professional guides on the San Juan and Colorado. Those who followed were boatmen he trained or inspired. Their names are legend in Glen Canyon country—Bus Hatch, "Moki Mac" Ellingson, Al Quist, Georgie White, Kent Frost, Ken Sleight, and, of course, Frank Wright and Jim Rigg, who took over Nevilles's operation and renamed it Mexican Hat Expeditions.

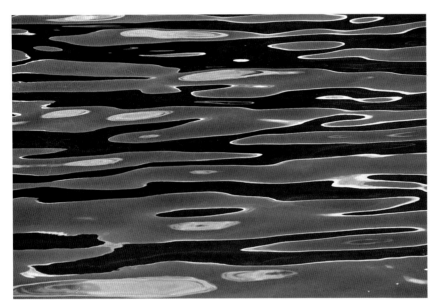

REFLECTIONS, FACE CANYON

Then there was Art Greene, who proved himself considerably more than a river runner. From his Marble Canyon Lodge near Lee's Ferry, he began in the late 1940s airboating paying passengers upstream to Forbidding Canyon and the hike to Rainbow Bridge. Learning, in 1953, of plans to build a dam in lower Glen Canyon, he shrewdly leased 3,840 acres of Arizona state lands around Wahweap Creek and sat tight against all Bureau of Reclamation and Park Service efforts to push him out. Ten years later, when water was backing up to the Park Service's new 200-foot-wide

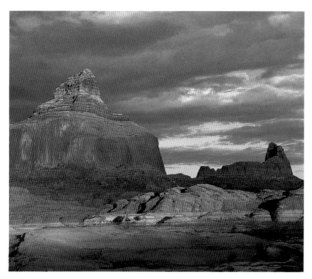

BOUNDRY BUTTE, SUNSET,
LABYRINTH CANYON

Wahweap Marina, Greene was doing just fine with a general store, cafe, campground, and trailer park nearby. Through all changes of ownership and development at Wahweap, including the $70 million purchase of lake operations in 1988 by Philadelphia-based ARA Leisure Services, Greene's trailer park has remained independent and privately owned.

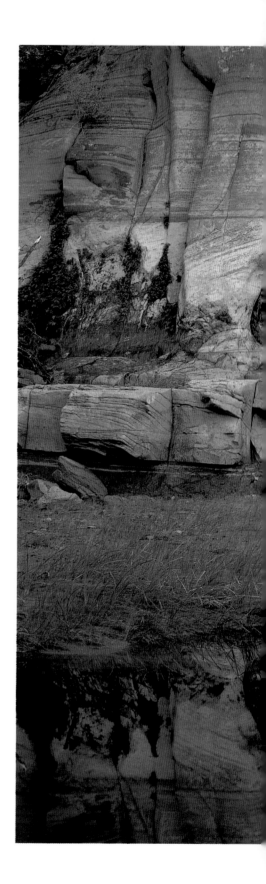

WALL, GRASSES & POND,
COTTONWOOD CANYON

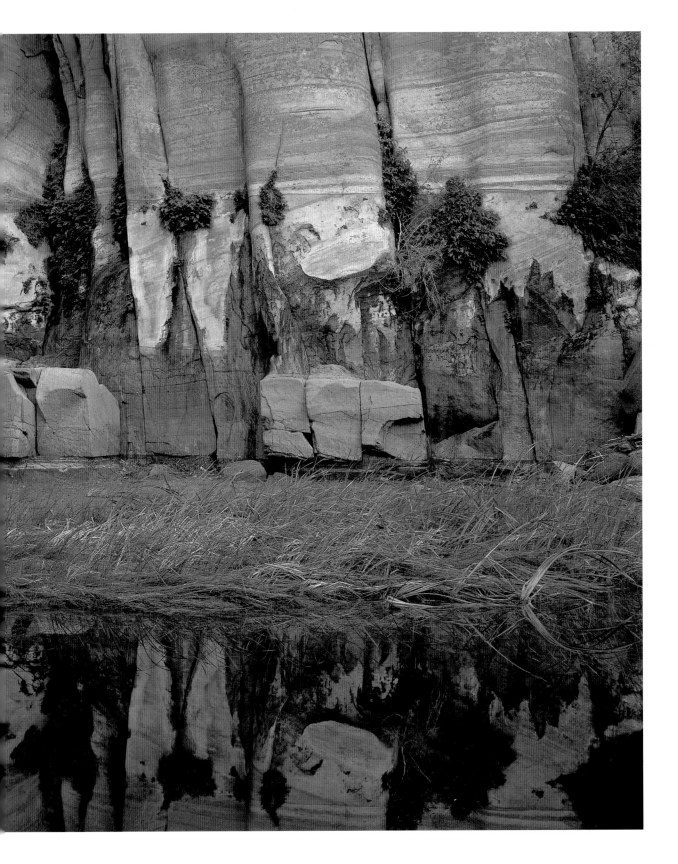

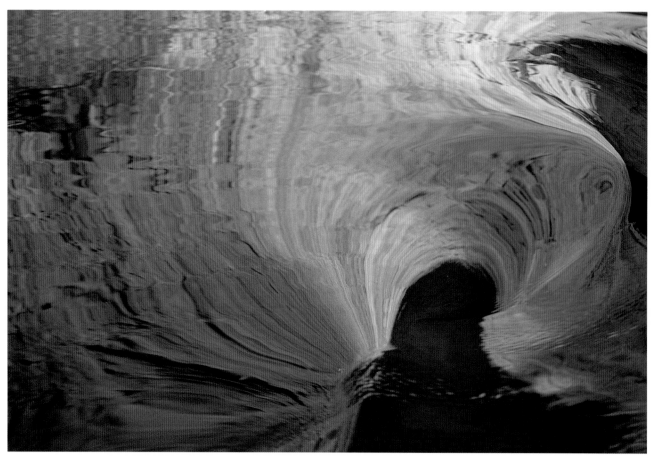

REFLECTIONS, REFLECTION CANYON

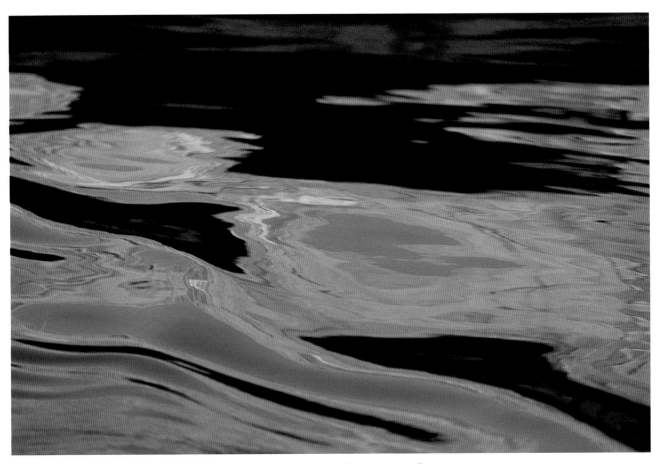

GOLD REFLECTIONS, CASCADE CANYON

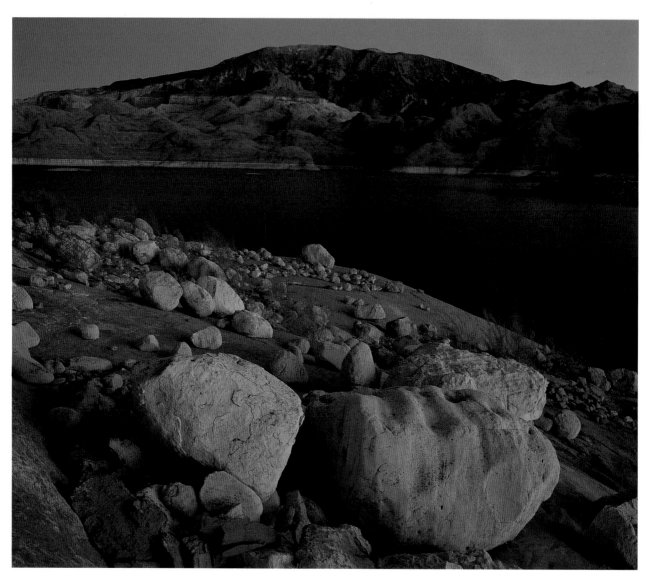

Navajo Mountain, sunset glow

LAKE POWELL
TODAY

In Lake Powell's earliest days, I scrambled to the top of Rainbow Bridge, something the Park Service now strictly forbids, with then-Secretary of Interior Stewart Udall and the Sierra Club's David Brower. We sat there an hour, then two, marveling at the slickrock wilderness sprawling down from Navajo Mountain and pondering how to protect the bridge from the inexorably rising waters. Build coffer dams above and below the bridge and pump the waters of Bridge Creek into the lake? The environmental damage to such a wild and beautiful place was unthinkable. Restrict the lake to a level below the bridge's elevation? That, the Bureau of Reclamation argued, would compromise the project's payoff and be politically impossible. Let the water rise and hope for the best? That seemed the only course.

So the water rose, creeping under the bridge, then, in the high water of the eighties, on up Bridge Creek. As the dry years returned, the lake fell, leaving silt twenty feet deep under the bridge and beyond.

But there is hope in nature's cleansing power. Flash floods have scoured away most of the silt. On a recent visit, I scrambled down to the streambed

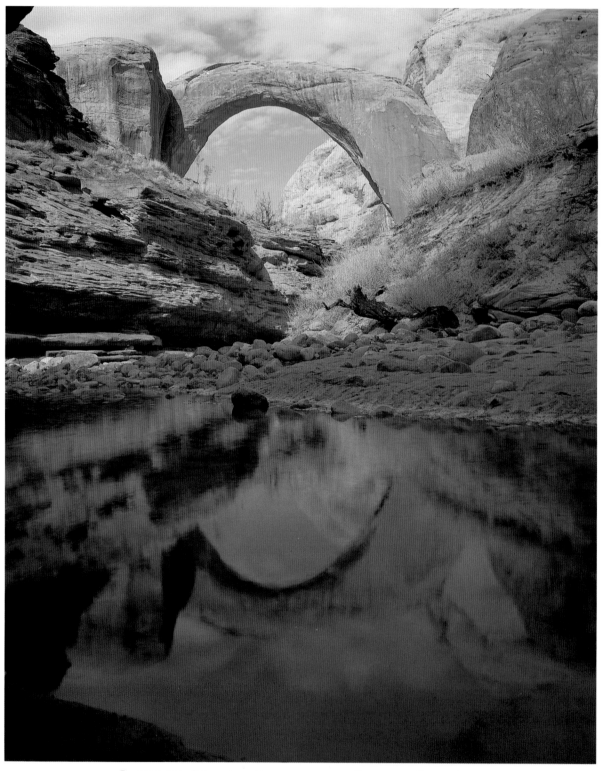

RAINBOW BRIDGE, REFLECTION, BRIDGE CREEK

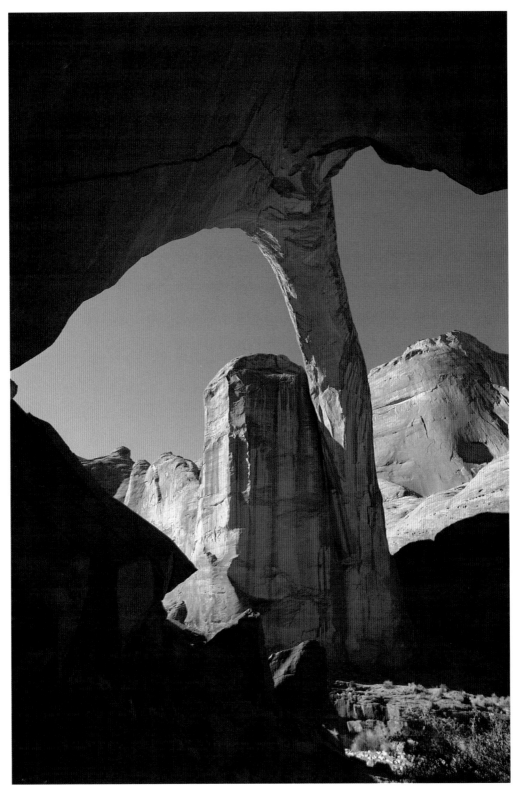

RAINBOW BRIDGE

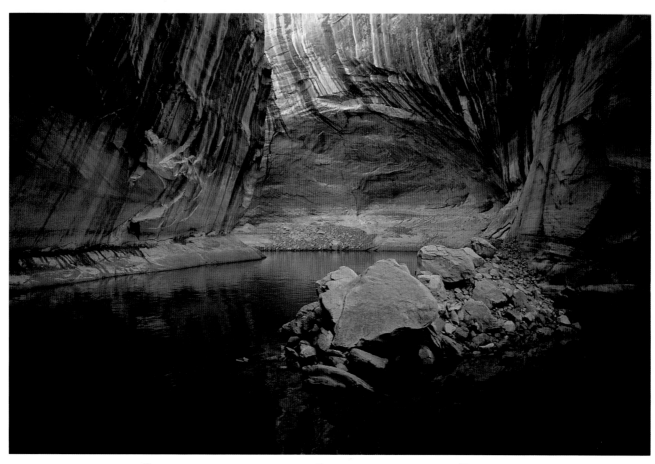

ROCK PILE AND WALLS, CATHEDRAL IN THE DESERT

above the bridge and spent my time there, where silt once was, photographing bridge reflections in tiny pools and the sheen of water on cobblestones as beautiful as they ever were. The only way to feel the silent majesty of this place is by hiking upstream away from the chattering throngs, seeing Rainbow Bridge as John Wetherill and companions saw it for the first time on that day of discovery in 1909.

I have another kind of hope—that with time and education, the crowds of visitors might come to feel something special there—like a French family who approached the bridge, shoes in hand, walking barefoot on the sandy trail. "We read that this place is sacred to the Indians," they explained. "We want to honor that sacredness."

They were right; it is sacred. Navajos bring pollen with water from sacred springs on Navajo Mountain to perform their chants and make offerings. Given advance notice of the pilgrimages, the Park Service closes the area to others for twenty-four hours during that time. There's a Navajo legend, supposedly, about the gods creating a frozen rainbow over which beleaguered warriors could escape. More meaningful is a prayer Indians chanted before they dared walk under the bridge. That prayer, learned by John Wetherill's wife Louisa from an old Indian, speaks of sacred Navajo Mountain, the rock rainbow, and the four winds—

dark wind of the north, blue wind of the south, yellow wind of the west, and many-colored wind of a bright day. The first stanza, repeated for each of the winds, goes like this:

Mountain where the head of the War-God rests,
Mountain where the head of the War-God rests.
Dark Wind, beautiful chief,
* from the tips of your fingers*
a rainbow send out,
By which let me walk and have life.
Black clouds, black clouds, make for me shoes,
With which to walk and have life.
Black clouds are my leggings;
A black cloud is my robe;
A black cloud is my headband.
Black clouds, go before me; make it dark;
* let it rain*
peacefully before me.
Before me come much rain to make
* the white corn grow and ripen,*
That it may be peaceful before me, that it may be
peaceful before me.
All is peace, all is peace.

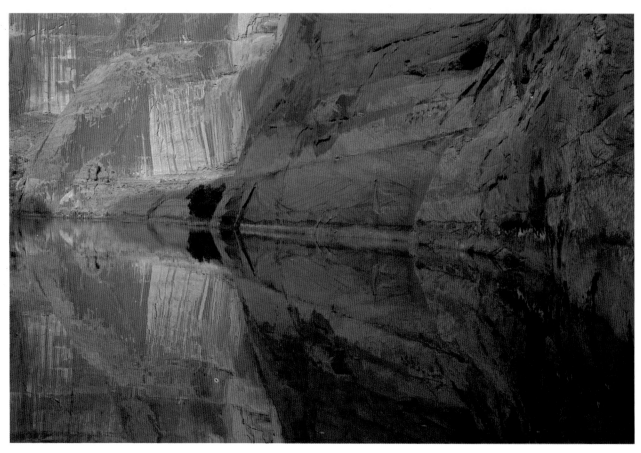

REFLECTION, CANYON

LOOKING
AHEAD

MORE PEOPLE WITH A BIT OF reverence could do wonders for the rest of the lake as well. For thirty years, boaters have treated it as a dump, their discarded trash hidden under the velvety blue waters. The drought-driven drawdown of recent years showed the shameful results. Receding water exposed unbelievable trash—sofas, a refrigerator-freezer, a toilet and sink, countless batteries—200 of them around Wahweap Marina alone—truckloads of beer and pop cans.

Thankfully, something is being done about that. In an innovative cooperative effort between ARA Leisure Services, the Park Service, and various companies, volunteers spend a week at a time on a houseboat called the Trash Tracker, collecting trash and depositing it in an accompanying barge. Plenty of people volunteer—thousands for the few hundred slots available each year, and no wonder; as we approached the Trash Tracker in Friendship Bay on a recent visit, an elderly volunteer informed us he had limited up with large-mouth bass in an hour and a half.

A tougher problem is that of human waste. In 1992, for the first time ever, the Park Service closed beaches—eight of the most popular ones—because of pollution. That outrage won't be solved

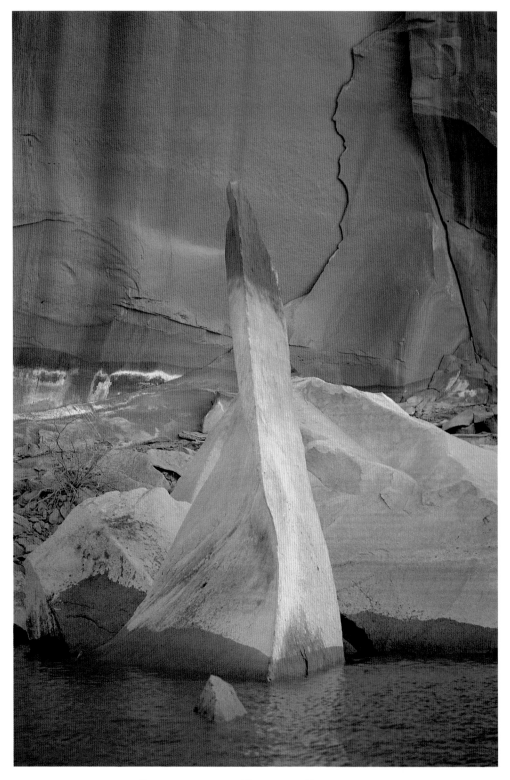

RAZOR ROCK, COYOTE CANYON

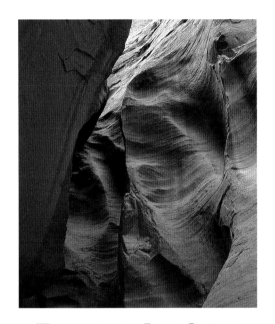

WALL DETAIL, FACE CANYON

until all boats, even small ones, are required to carry portable toilets, and stiff fines are imposed for dumping waste or using the beaches as toilets. That will require better waste disposal facilities at marinas and perhaps floating restrooms and disposal stations on the lake. This will take money, which higher launch fees could provide.

For a third problem—that of fluctuating lake levels leaving a bathtub ring on the cliffs, drowned trees, mud flats, and acres of Russian thistle left by receding water at the mouths of side canyons— there is probably no solution. The depth of snowpack in the Rockies, Wind Rivers, and Uintas,

and thus the run-off down the Green and Colorado, is beyond human control. Still, at least we should expect— and demand—more intelligent dam management than we saw in 1983-84. Anyone who could read a snowpack report that winter knew what would come down the rivers in the spring. Anyone with that knowledge should have been foresighted enough to let water out of the brim-full lake, making room for the runoff. Because no one did, the lake rose seven-and-a-half feet above capacity, leaving that much more bathtub ring, silt and thistle. Floodwaters washed out the right-hand diversion tunnel so badly it had to

be rebuilt, and for a time it appeared the dam itself could go.

Many of Lake Powell's three-and-a-half million visitors know only what they see when they take a cruise boat ride for a quick look at Rainbow Bridge. Yet, for those who remain or return, each trip can be one of discovering little-known places like Twilight Canyon with its no-name arch; Secret Canyon; Cascade Canyon, inaccessible in Glen Canyon days behind a waterfall and hanging garden is now a narrow, serpentine passage, its quiet water holding wondrous cliff reflections; or Face Canyon, a classic slot canyon where a skillful driver in a small boat can wriggle through the narrow,

twisting channel to water's end. From there, one walks on until he can only squeeze through sideways, then not at all, realizing the power of water as nature's carving tool.

Glen Canyon reveals itself best to those who leave their boats and get into the back country. There are splendid hikes, such as the one beyond Rainbow Bridge, as far as one cares to go into the naked slickrock wilderness flowing down from Navajo Mountain; or up Long and Bowns canyons, opposite the Rincon, where one can splash along Navajo Creek, soak in water pocket pools, explore for the fossilized sloth dung that has been found there. My favorite hike in all the Glen Canyon country is a four- or five-day backpack

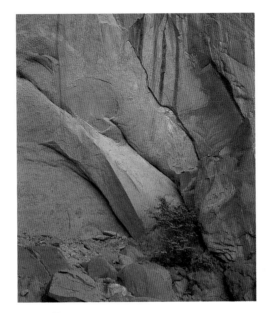

REDBUD IN SLICKROCK,
ECHO CAMP

down Coyote Canyon past Jacob Hamblin Arch and Coyote Bridge to Coyote's confluence with the Escalante—which, sadly, the lake's high water drowned, leaving a quarter-mile of mud extending up each canyon. Once past that, it's up the Escalante to Stevens Arch, then up Stevens Canyon, swimming through arms-width crevices, looking for Moki steps up impossible slopes, swallowing the taste of fear as one ascends them. Eventually, one climbs out of Stevens and explores across the Waterpocket Fold to Halls Creek Bay for a boat pickup—if one can push through hundreds of yards of shoulder-high Russian thistle to reach water's edge.

In a short, unnamed side branch of Cottonwood Canyon lies a quiet pool at the base of an alcove lush with hanging gardens. Sunlight never reaches here, but light reflected off the cliff above bathes the pool and its grotto in soft, bluish tones. Above on the right soars one of the most perfect tapestry walls in Canyon Country. Alternating stripes, some broad, some narrow, flow down the wall—rust, beige, purple, violet, ocher, gray, indigo, red. All are in muted tones; surely it was patterns and colors like these that inspired the quiet desert tones of Navajo rug weaving.

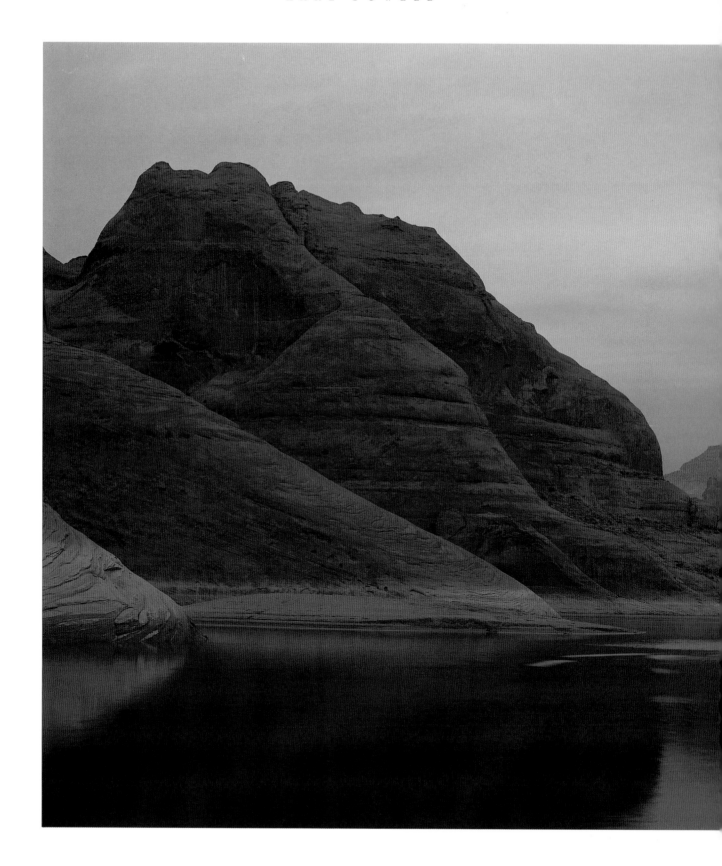

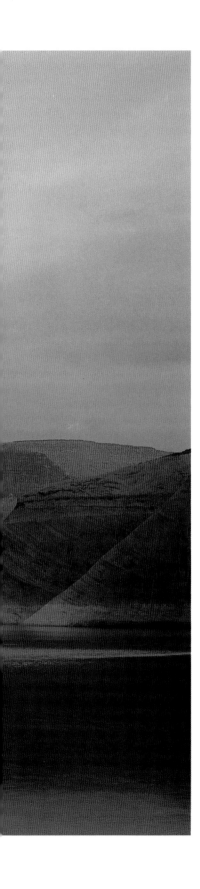

SUNRISE,
OAK CANYON

After scrambling up a sand-and-scree slope to photograph that wall, I sit to contemplate its beauty. Against the opposite wall a pair of ravens play with their shadows. Tiring of that, they decide to practice landings, the target a tiny knob high under the overhanging cliff. Precisely like student pilots doing landing drills, they make pass after pass, trying to hit the landing just right. A graceful, swooping turn or two, then four or five purposeful wingbeats to the ledge. Three passes, four—not quite right. Then, on the fifth pass, success; the landing is perfect. A brief pause, and then a takeoff to repeat the practice.

Time to rest—and show off. Overhead the beat of wings, a soft whoosh whoosh like a muffled helicopter, and raven lands in a nearby scrub oak. His conversation is a four-note chuckle followed by a soft, froglike double croak, not unlike a chicken clucking, which may explain why the Navajos call the raven "desert chicken."

Seeing me raise binoculars for a closer look, he deliberately—almost arrogantly—turns to show the sheen of his blue-black back feathers, keeping his head in classic silhouette. Then he's off down canyon with slow wing beats, flinging back raucous insults that only a friend would accept with a smile.

If raven is the friendly presence of Lake Powell, light is its magic. In the predawn, advancing day

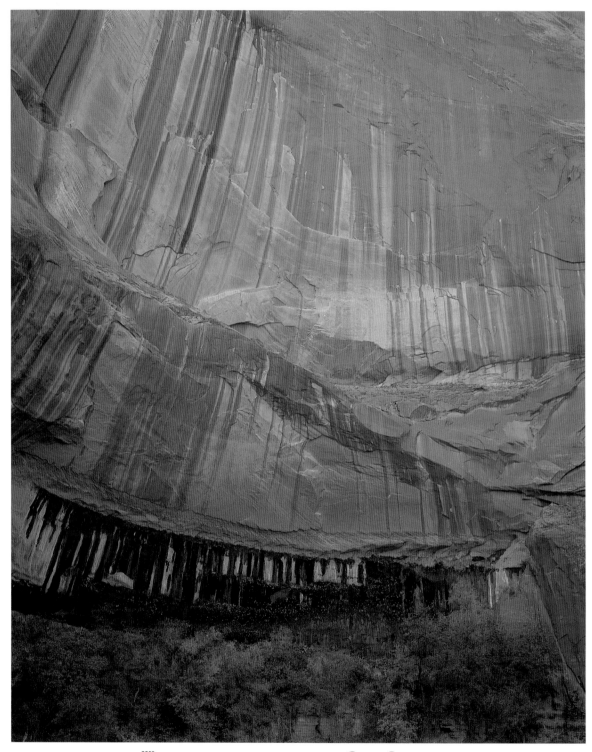

WALL DETAIL AND FOLIAGE, COW CANYON

lights the buttes and cliffs with an inner glow. What photographers call "sweet light" comes at sunrise, lasts an hour or so, and returns an hour before sunset. Shadows deepen to purple against the red and orange highlights still touched by the sun, and the real enchantment begins as the post-sunset glow again lights in the buttes their inner fire.

In most places, knowledgeable photographers put cameras away in the hours between the sweet light, but not here. Then it's time to go into the deep canyons where sunlight never reaches, but where light reflecting and refracting off the cliffs above is a photographer's enchantment. Colors change. So do patterns, textures.

I spent an evening watching the sunset from high on the miners' stairs opposite Aztec Canyon. Across the lake, the naked sandstone stretched up to Navajo Mountain, within which still seethes the molten, surging magma that once pushed up this great igneous bulge. Creation is not yet finished in this sacred mountain, whose cliffs, fissures, domes, and labyrinthian canyons suggest the bubbling, heaving cauldron that once ruled here.

The post-sunset glow faded, leaving the cliffs and buttes virtually dark. High on the slopes of Navajo Mountain, a sandstone castle caught the last gleam of sunlight, glowing against the darkness. A few moments of wonder, and it was gone. But not its memory. Nor its promise.

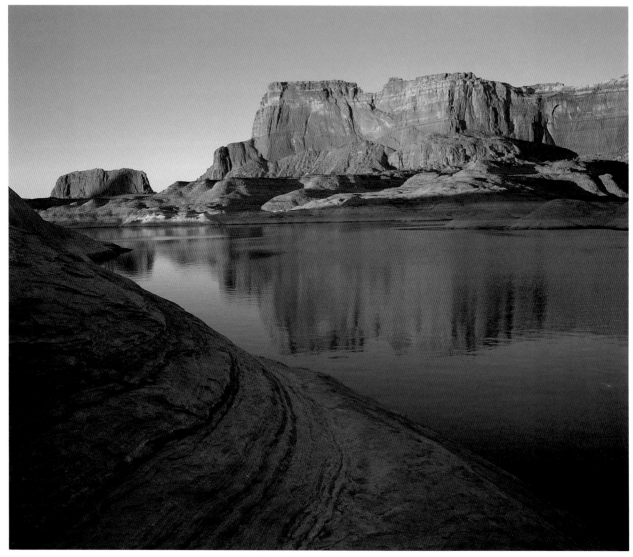

SUNSET, FACE CANYON

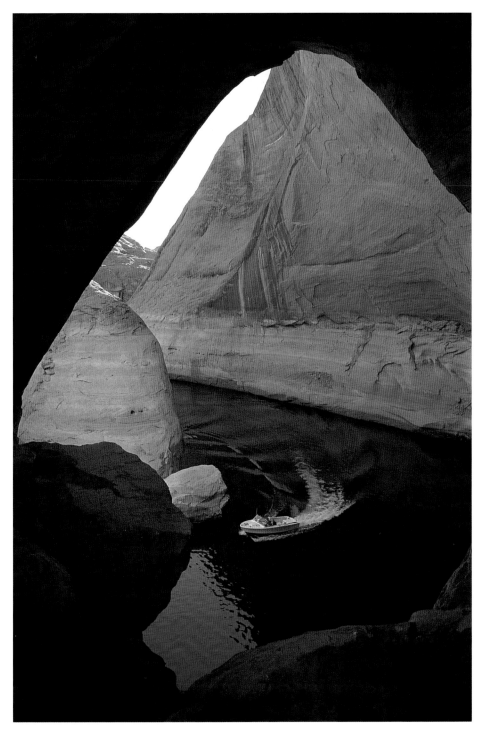

LAGORCE ARCH

BIBLIOGRAPHY

Abbey, Edward. *Slickrock.* Sierra Club, 1971.

Bolton, Herbert E. *Pageant in the Wilderness: The Story of the Escalante Expedition, 1776, Including the Diary and Itinerary of Father Escalante.* Utah State Historical Society, 1976.

Chronic, Halka. *Roadside Geology of Utah.* Mountain Press Publishing Co., 1990.

Dellenbach, F. S. *A Canyon Voyage.* Yale University Press, 1962.

Crampton, C. Gregory. *Ghosts of Glen Canyon.* Publishers Place, 1986.

Crampton, C. Gregory. *Land of Living Rock.* Alfred A. Knopf, 1972.

Crampton, C. Gregory. *Standing Up Country.* Alfred A. Knopf, 1964.

Kelsey, Michael R. *Boaters Guide to Lake Powell.* Kelsey Publishing, 1991.

Martin, Russell. *A Story That Stands Like a Dam.* Henry Holt, 1989.

Miller, David. *Hole-in-the-Rock.* University of Utah Press, 1959.

Miller, David, ed. *The Route of the Dominguez-Escalante Expedition.* Utah State Historical Society, 1976.

Morgan, Dale L., ed. *The Exploration of the Colorado River and High Plateaus of Utah by the Second Powell Expedition of 1871-72.* Utah State Historical Society, 1948 and 1949.

Porter, Eliot. *The Place No One Knew.* Peregrine Smith Books, 1988.

Powell, John Wesley. *The Exploration of the Colorado River and Its Canyons.* Dover Publications, 1961.

Stegner, Wallace. *Beyond the Hundredth Meridian.* Houghton Mifflin, 1954.

Stokes, William Lee. *Geology of Utah.* Utah Museum of Natural History, 1965.

Warner, Ted J., ed. *The Dominguez-Escalante Journals.* Brigham Young University Press, 1976.